IMAGES
*of America*

# LA PORTE

## INDIANA

## AND ITS ENVIRONS

IMAGES
*of America*

# LA PORTE

## INDIANA

## AND ITS ENVIRONS

La Porte County Historical Society, Inc.
*Archival Preservation Committee*

ARCADIA
PUBLISHING

Published by Arcadia Publishing
Charleston SC, Chicago IL, Portsmouth NH, San Francisco CA

Printed in the United States of America

Library of Congress Catalog Card Number: 2002102839

For all general information contact Arcadia Publishing at:
Telephone 843-853-2070
Fax 843-853-0044
E-mail sales@arcadiapublishing.com
For customer service and orders:
Toll-Free 1-888-313-2665

Visit us on the Internet at www.arcadiapublishing.com

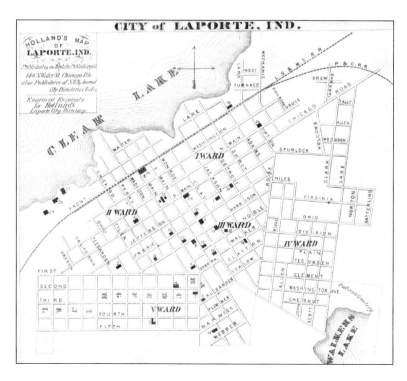

Holland's
Map of the
City of La Porte,
IN, 1871-72.

# CONTENTS

# ACKNOWLEDGMENTS

The La Porte County Historical Society, Inc., Archival Preservation Committee has, since its inception eleven years ago, focused on preserving not only the archival materials in the collection of the society, but in assisting interested organizations in the preservation of their archival materials. Fern Eddy Schultz was the force behind the founding of this committee and continues to be the chairperson of the committee. For the purposes of the preparation of this publication, she is considered the Author. However, the book is attributed to the La Porte County Historical Society, Inc., Archival Preservation Committee. It was through her efforts, combined with those of James Rodgers, Curator of the La Porte County Historical Society's Museum, that this book has come to fruition. She accepted the responsibility of the text and he selected the photographs from the society's large photograph collection. Other members of the Archival Preservation Committee, Robert Glassley and Walter Reeves, voiced their approval of an endeavor to produce this book as a preservation project.

Because of the generosity of La Porte County, Indiana residents and those who have ties to this county, the photograph collection of the society has grown over the years and is a valuable asset, not only to those interested in research, but to the perpetuation of the history of the county. It is a well-established fact that a photograph holds so much more and different information than can be put into words. Although members of the Archival Preservation Committee have changed over the time it has been in existence, the current committee is credited with having the ability to recognize the importance of utilizing this fine collection to advantage and sharing the history with others.

The hope of the committee is that this will be an inducement to those who have not yet "found a home" for some of those photographs of historical nature about La Porte County stored in shoe boxes, etc., in their homes, to think seriously about donating them to this collection. If individuals desire to maintain the original photograph, the society presents the offer of making copies of them, storing them on disk, and returning the original to the owner. This is an excellent way of sharing the photographs with others and still maintaining the originals in family files. It also assures us that the historical information will not be lost to posterity.

Any proceeds from this book will benefit the Archival Preservation Fund.

# INTRODUCTION

Before 1830, all of La Porte County, Indiana was a part of the Pottawatomie Nation. All of the land from the Wabash River to Lake Michigan belonged to the Pottawatomie Indians. They were a peaceful people and had trails or traces that ran through the forests and marshes, around the lakes, and along the rivers and creeks. In 1838, they were removed by the U.S. Government to the Osage County of Kansas. Many of these Indians were old and could not stand the long trip and died on the way, so it has been called the March or Trail of Death.

The State of Indiana enacted a ruling that after April 1, 1830, all of Northwestern Indiana from the county of Elkhart to the state line on the west be designated as St. Joseph County and that five districts or townships be formed. Two districts to the west were called Highland and Michigan; two districts to the east were in what is now St. Joseph County; and the center district, later a part of the present La Porte County was named "Descheim," French for— "by the lakes."

Then, a move was made to make La Porte a separate county. As a result, La Porte County, consisting then of 462 square miles, was incorporated. It became an official county on May 28, 1832. The county was divided into three districts or townships designated as Kankakee, Scipio, and New Durham. Later, these three townships were divided into others and on January 8, 1842, a portion of what was Starke County, located to the south of the original La Porte County, became a part of the county. Today, La Porte County consists of 21 townships.

In October 1831, the area which eventually would become the town of La Porte was purchased at a land sale in Logansport, Indiana, by Walter Wilson. Wilson was the designee of his partners, John Walker, Hiram Todd, and the brothers, James and Abraham Piatt Andrew Jr. The land purchased was known as "Michigan Road Lands" and the purchase was made with the idea in mind of laying out the town and making it the county seat. The town was laid out in 1832, and at that time there were only 525 residents in the entire county. By 1840, this number had increased to 8,184. In 1990, the population of the City of La Porte alone was 21,507.

During the Civil War period, many from the county participated and there were casualties. There were two Civil War camps located in the vicinity of La Porte; one at the west edge of town, Camp Colfax, and one at the northeast edge, Camp Jackson. A hospital for Union Army casualties was also constructed at the corner of First and "C" Streets and is today used as a residence.

La Porte has had some rather large industrial manufacturing firms located here, including the Rumely Company, which later became Allis-Chalmers Manufacturing Company. This firm manufactured agricultural equipment and for many years was the main employer in La Porte. However, the facility is no longer in existence. It closed a number of years ago and in its location is a shopping center. Much of the industrial base of La Porte has evolved into small industries replacing the larger ones and service industries replacing manufacturing.

Being the county seat, government offices are located within the government complex which includes the La Porte County Court House and a separate building housing some of the

government offices as well as the La Porte County Jail. The present court house is the third to be built on that same site. The cornerstone for this structure was laid June 30, 1892.

Tourism is a popular industry today. La Porte has much to offer the tourist. In the summer months, the numerous lakes are ideal for boating, fishing, and swimming; and snowmobiling and ice fishing are popular winter activities. One of the finest historical society museums in northwest Indiana is located in La Porte. The La Porte County Historical Society Inc.'s Museum, located in the government complex at 809 State St., has been awarded a commendation from the American Association for State and Local History. Also at the south end of La Porte is the Door Prairie Auto Museum which is a must for the antique auto "buff."

La Porte County is at the southern tip of Lake Michigan with Michigan City located within its county lines. It is only a 12-mile trip from La Porte to enjoy one of the Great Lakes and all of its recreational offerings. To reach the many activities offered throughout the county, is only a matter of a few minutes' drive. In recent years, festivals have come into being, particularly in the fall months, in almost every village and town in the county, each with a different theme. La Porte has recently inaugurated the Sunflower Festival and it has become a well-attended and popular event.

As with the turn of the 19th century, it is certain that the 21st century will bring changes that some might designate as "unheard of" for La Porte. But as time goes on, they will all become a piece of our history and perhaps become part of a future pictorial history book.

# One

# RESIDENCES

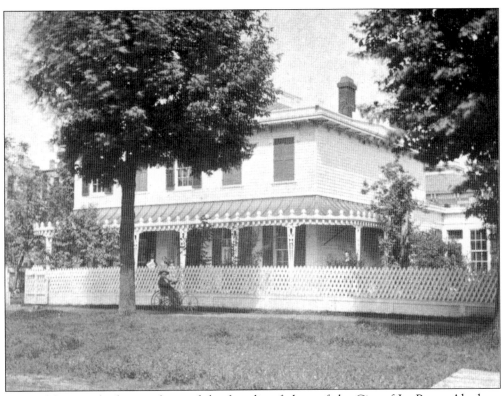

Pictured here is the home of one of the founding fathers of the City of La Porte, Abraham Piatt Andrew Jr. and his wife, the former Viola J. Armstrong. This home was located on the southeast corner of West Main (Indiana Avenue) and Jefferson. Porches were thought to assist in air circulation and by the 19th century they were being added to many homes. Notice the lattice-type fence surrounding the home setting. One of the family members or a visitor is seen on a bicycle in front of the fence. The house was sold in 1907 to Dr. H.H. Long, Dr. I.P. Norton, and J. Vene Dorland for $8,000. They would not reveal their exact plans for the future of the site but indicated offices might be constructed there. Mrs. Mary Benner conducted a boarding establishment here for several years before this transaction. Mrs. Andrew died Christmas Day, 1883 and Mr. Andrew died in 1887. Both are buried in the Andrew plot in Pine Lake Cemetery. This was later the site of the Masonic Temple Building.

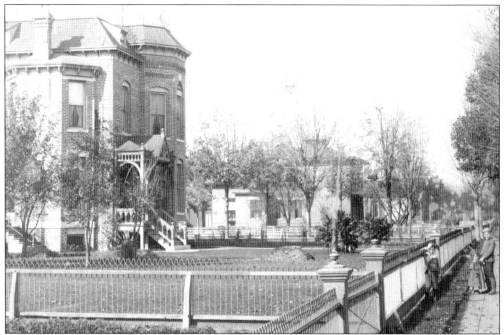

This picture, taken about 1890, shows the house built by Seth Eason. He and his family resided here for many years. It was later owned by Samuel Fox and the Fox children pose outside the fence. Fences played an important part in separating one lot from another and a variety of materials were used in their construction. The roof features with the ironwork are of particular interest. The house was razed in 1971.

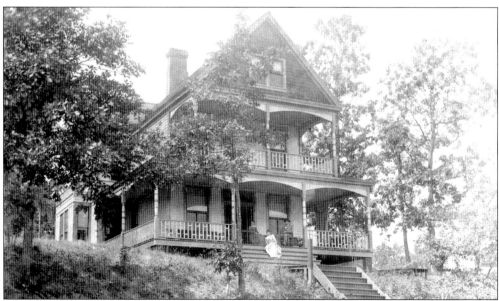

Atop the hill by Pine Lake is one of the many "cottages" erected as summer homes for local and out-of-town residents. A few steps from the house lies the lake where swimming was enjoyed and often boats were launched for fishing. Many just enjoyed the cool breezes and the view from the porch.

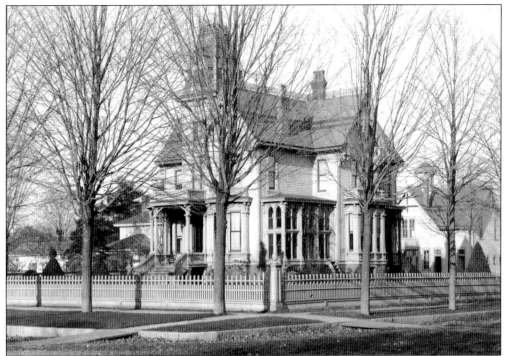

The Thomas Jefferson Foster home was located where the First United Methodist Church is today at the corner of Michigan Ave. and Alexander St. Foster was a grocer and ran a "first class" bakery on Main St. Fencing with decorative corner posts surrounds the lot. The cupola and roof feature attractive ironwork to add to the beauty of the house.

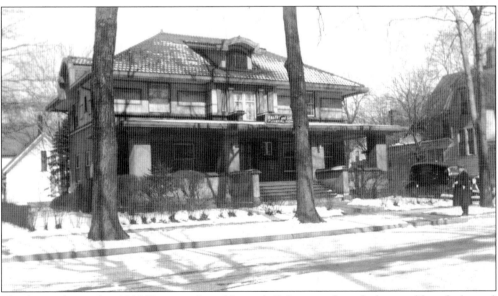

This home, located at 1007 Harrison St., of Spanish Eclectic style with the notable red tile roof, was built by Aloysius J. Rumely for himself and his bride, the former Hannah Berghoff. They were married on June 9, 1909. Most recently, the home is known as the location of the Giese Funeral Home.

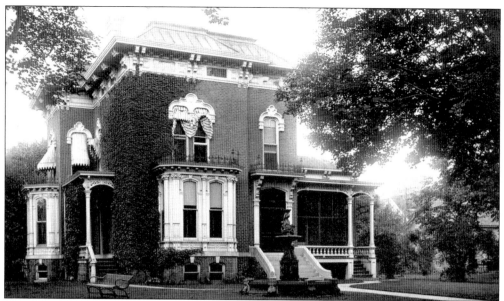

Known as the Truesdell home, this house was located on the northwest corner of Michigan Ave. and Alexander St. Decorative brackets on the frieze were indicative of this period. The ever-popular porch, although only on one side, was still an important part of the structure. The two visible bay windows add to the beauty of the house and the fountain on the front lawn was a particularly attractive part of the landscape.

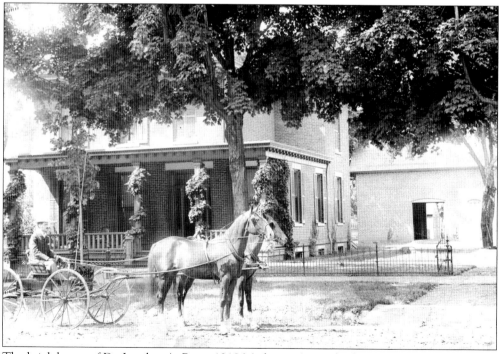

The brick house of Dr. Landon A. Rose, 1218 Michigan Ave., also has a brick barn in the rear. The lot is surrounded with an iron fence. A son of Dr. Rose waits in a horse-drawn buggy in front of the house. Furniture on the porch indicates its usage as a place to enjoy the outdoors.

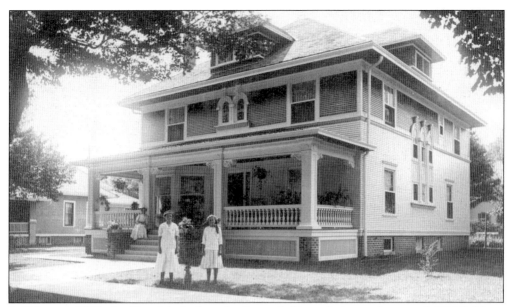

In February, 1905, the Kent M. Andrew family settled into their new home at 1408 Michigan Ave. It had the familiar colonial effect with a spacious veranda. The upper floor consisted of five commodious chambers and a tiled bathroom finished in nickel trimmings. Mr. Andrew was the son of Charles A. and Indiana C. (Andrew) Marvin who died when he was very young. He was reared by his maternal grandparents, Judge and Mrs. William P. Andrew.

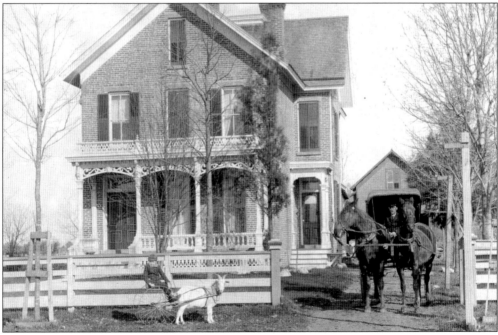

Brick was becoming more available in the area by about 1845, so it became a construction material of choice. This house is reported to have been built by Aaron Henderson Miller and was later sold to George Dorland. It is located at 1805 Michigan Ave. The board fence surrounds the property with the gate opened to allow the gentleman with his horses and buggy to exit.

Prosper "Pop" Hollenbeck resided in this typical frame house north of La Porte in Center Township having come with his parents in 1852. Generally speaking, the more lights in each section of a window, the older the house. Here we note 6/6 in all of the windows. The two ladies in the wicker rocking chairs are possibly enjoying time out of the kitchen.

Records would indicate that this home at 1405 Indiana Ave. was that of Joseph Guggenhime/ Guggenheim at least as early as 1871. He was born in Germany and came to La Porte in 1852 and started a mercantile business with Jacob Wile under the name of Guggenhime & Wile which later became the La Porte Woolen Mills. The pillars in the front of this house add to its unique architecture.

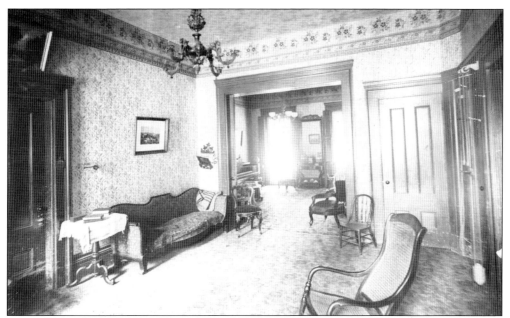

This is the parlor-sitting room area of the Abraham Piatt Andrew Jr. home seen on page 9. The house stood where the Masonic Temple Building is now located. Notice that wallpaper is used throughout and the lighting instruments are all ceiling fixtures. A piano was an important piece of furniture in most homes.

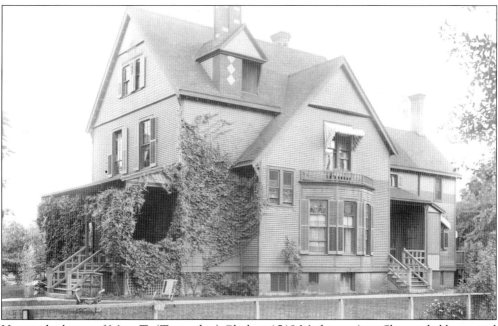

Here is the home of Mary T. (Teegarden) Clark at 1518 Michigan Ave. She resided here until her death in 1922. She was a native La Portean, born here in 1846, and the oldest daughter of Dr. Abraham and Laura (Treat) Teegarden. The house embraced attractive bay windows. The yard was fenced, as were many of this period, to prevent strays from entering the property. The ivy provided shade for porch users and added to the beauty of the residence.

George L. McLane was described as a "merchant and capitalist of La Porte" and was a native son of the county having been born in Noble Township. This is the first house he and his wife, the former Mollie Josephine Baird, owned in Union Mills. We note the decorative pillars on the porch and the board fence surrounding the property. Their son, Howard, became a prominent businessman in La Porte.

The Annis Homestead was located on the northeast corner of Rose and Division Sts. Eber Leander and Samantha J. (Newton) Annis came to La Porte in 1845. Their son, who was named after his father, became a prominent La Porte doctor. This small frame house is where the future doctor was born on May 19, 1860. The house and lot is encompassed by a picket fence. This may be the good doctor with his horse and buggy on the way to a patient.

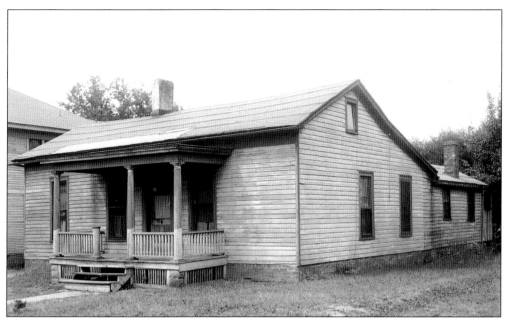

A history of La Porte County states that the house at 1202 Jefferson Ave. was built by Dr. Dinwiddie in about 1837. A local newspaper indicates its location was at 1307 Jefferson Ave. and was moved to 815 Division St. This was the first house of Dr. Dinwiddie and he was one of the first physicians in La Porte.

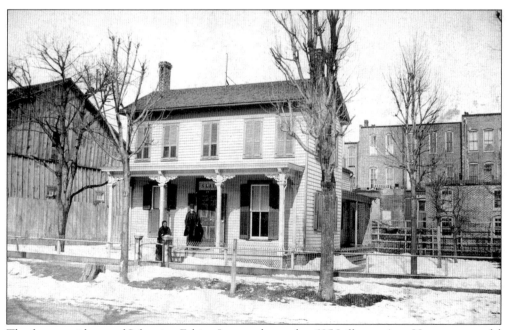

The frame residence of Sebastian Fabian Lay was located at 605 Jefferson Ave. He was successful in his many undertakings and after his first marriage, resided on a farm outside the city. He made a specialty of raising maple trees and many of the maple trees seen along the streets of La Porte were brought from his farm. He returned to the city in 1860, remarried in 1867, and this structure is the home where he and his second wife resided.

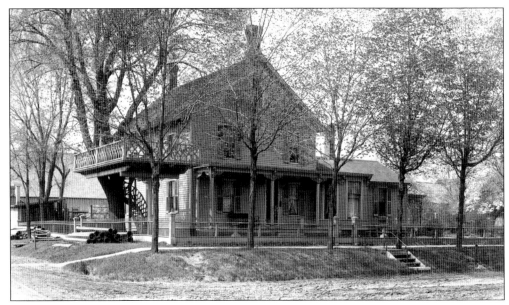

Home of Meinrad Rumely, founder of M. Rumely & Co., was located at 1111 State St. on the northeast corner of State and Chicago Sts., amid the Rumely factory buildings. Note the decorative porch posts that adorn the front as well as the fence around the yard. The added feature of a balcony has stairs from the lower level outside. The building to the north is recorded as being a "chicken house."

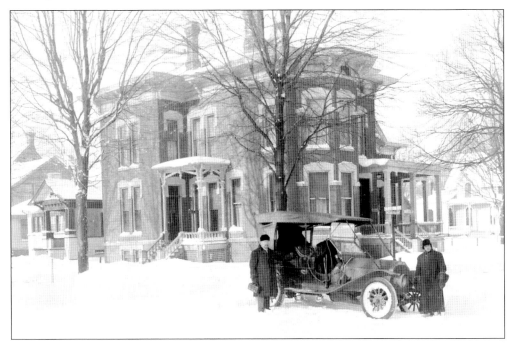

This home was originally built in 1875 by Simon Wile on the northwest corner of Indiana and Harrison Streets. It was later owned by Dr. H.H. Long who practiced for 15 years in Kingsbury before coming to La Porte. He is seen in this picture at the left with his automobile and chauffeur, Frank Engle. This red brick structure is still standing and has had several uses over the years.

# *Two*

# SCHOOLS

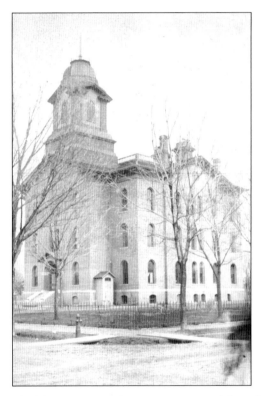

La Porte's first high school building was erected in 1864 at a cost of about $50,000. Its location was the square bordered by Harrison, Clay, Noble, and Jackson Sts., north of the area occupied by the old La Porte University which burned down several years prior. Contractors for its construction were J.M. Miles, Davidson Patton, and William W. Ash. There were two graduates in the class of 1869; Lester C. Houseman and John R. Walker. The school accommodated fifth through eighth grades with high school on the top floor. The large front door was used as an entrance, but later the side basement doors were arranged for entrance instead. The shuttered portion of the tower held a large bell which was added in 1870. The bell weighed about 1,400 pounds and cost $175. It was rung when morning and afternoon sessions were called and could be heard in all parts of the city. There was a stairway around the inside of the tower to the iron-fenced top, where pupils were permitted to view the town, lakes, and surrounding scenery on Friday afternoons.

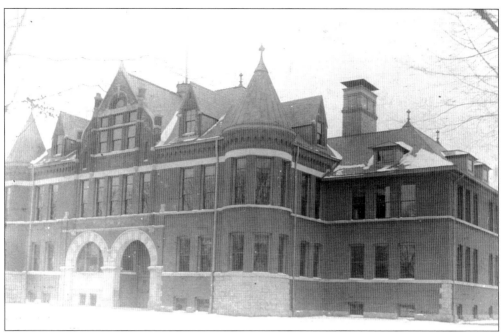

The "new" high school building was assured when the Board of Education, at their July 17, 1894 meeting, accepted the proposal of Wing and Mahurin, architects and builders of Ft. Wayne, Indiana. This "new" high school building was erected to meet the demands of the schools, caused by the growth in the number of pupils and the extension in work. Provision was made for 175 pupils. This building later became the Junior High School.

These students are "climbing the ladder of success" outside the entrance of the "new" high school. This building was soon to be known as the "old" high school as this photograph was dated 1924 and construction of yet another "new" high school was in process, scheduled to be ready for occupancy with the start of the 1924-25 school term.

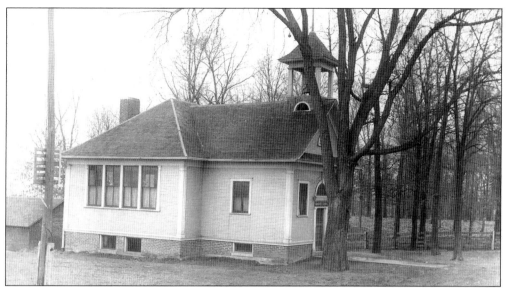

Kankakee Township School, east of La Porte, on what is called Pumping Station Rd., was reportedly built in 1906. Cloak rooms were separate from the main room and the structure contained a number of windows offering adequate lighting and ventilation. In compliance with the new sanitation law, it had running water and modern toilets. The belfry contained a bell used to call pupils to their studies from the large playground, which had some ball ground equipment, swings, and slides.

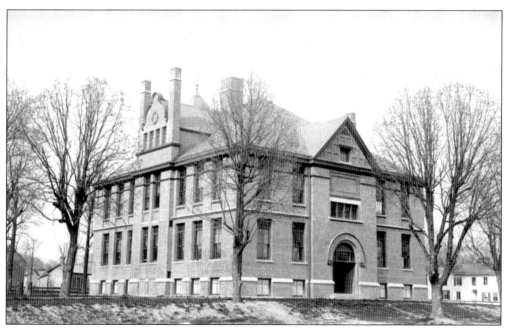

Park School, an eight-room schoolhouse to be located on First St., was contracted in 1896 at a cost of $15,241.71. One of its special features was an elevator for moving wood to the first and second floors and removing ashes. It contained seven regular school rooms and a kindergarten. It was heated by a furnace and ventilated by windows. Drinking fountains were provided on each floor.

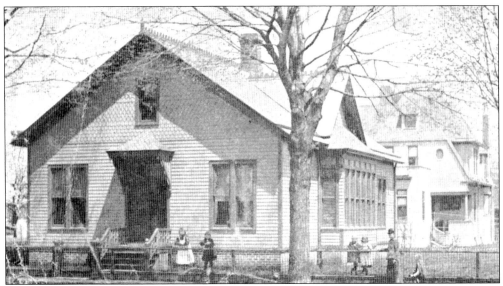

Hailmann Kindergarten, located on the northeast corner of Indiana Ave. and Osborn St. was established in 1889 by Eudora (Lucas) Hailmann. It was the second kindergarten west of the Alleghenies. She was the wife of Dr. William Nicholas Hailmann who, for many years, was Superintendent of the La Porte City Schools, and she actively supervised the work of this kindergarten group.

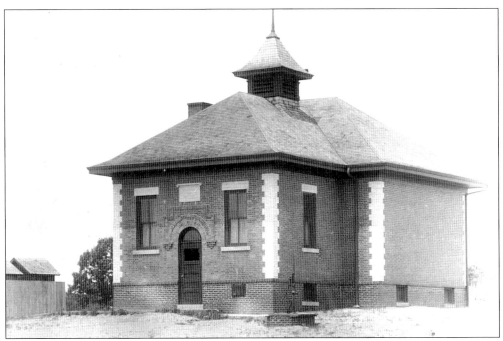

The school in the town of Otis in New Durham Township was referred to as a one-room school but in reality, it had two rooms and a basement. This building was built in 1911; the previous building was condemned for being unsafe. Patrons quite generally refused to send their children there and only one student was in attendance when it was abandoned. This new school was closed when the Westville School became a township school.

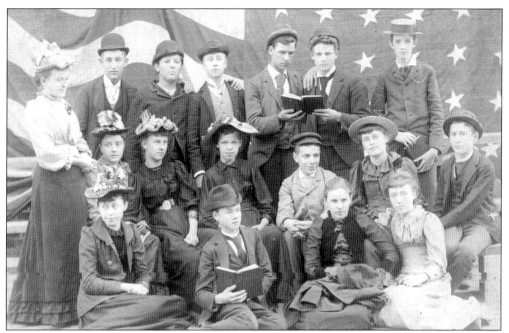

Members of the German class of 1893 at La Porte High School are identified as Fernald Cochrane, Roy Wilson, Sutton VanPelt, Frank Carter, Fred Butterworth, Norman Wolfe, Ruth Willoughby, Luella Hoagland, Clara Peglow, Cora Angell, Arthur Fox, Marta Davidson, Walter Davidson, Ora Hood, Kate Moore, Eddie Widdel, and Matilda Shultz.

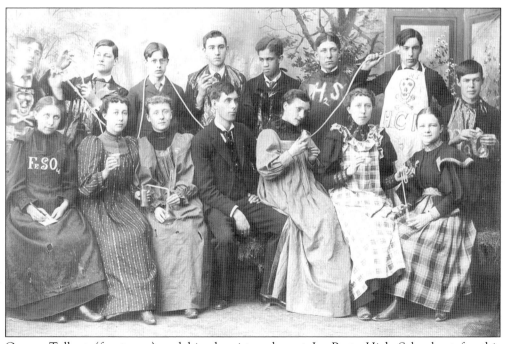

George Talbert (front row) and his chemistry class at La Porte High School sat for this photograph at the turn of the century. Then, as now, some of the students could not resist the temptation to ham it up for the camera.

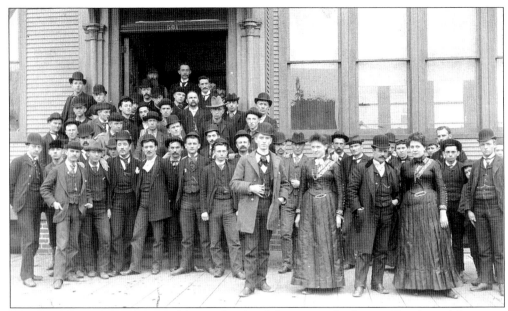

In 1886, James R. Parson started his trade school, known as the Parson Horological Institute, where optometry and watchmaking was taught. It was located at 501 Michigan Ave. and initially had an enrollment of three students. The course was 200-hours and covered all the things the optician needed for actual business. In 1892, the school left La Porte and became a part of Bradley Horological Institute in Peoria, Illinois.

Bryson School in New Durham Township derived its name from Ephraim M. Bryson, a Civil War soldier, who lived near the school and used to come and get water from the well. This is the first picture taken of the Bryson school group. Sometime during February, 1894, Charles and Henry Miller got out their bobsleds and gathered up the pupils ranging in age from 4 1/2 to 18 years old. One of the sleighs overturned on the way to the photographer. Many of the older boys could only attend during the winter because of their duties in the farm fields during spring and fall.

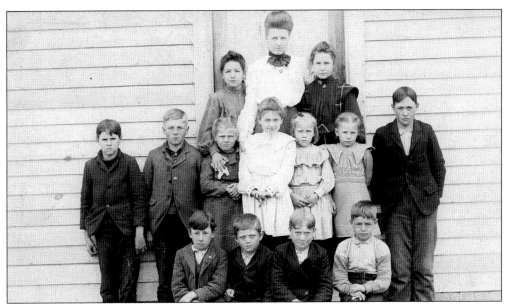

Never again was there to be a class of this size in a one-room school, heated by a stove, seated three in a seat and all drinking from the same old tin cup. William S. Travis was Trustee of Kingsbury in 1905, at the time his daughter, Bessie F., was the teacher at the local school. She was 18 years old, just having finished high school and passing the test to become a teacher of all grades. She reported that the man who hired her handed her a stove poker and told her to use it on the big boys if needed. The teacher who preceded her had left by the window after the pupils locked him in the school. Bessie did better than this; she took her brother, Clarence, with her and he helped maintain order. Left to right; (front row) Jesse Singleton Goss, George Kegebein, Clarence Lower; (second row) John Barnes, Clarence Travis, Ethel Harness, Laura Kegebein; (back row) Ida Lower, Bessie F. Travis (teacher), and Lizzie Lower.

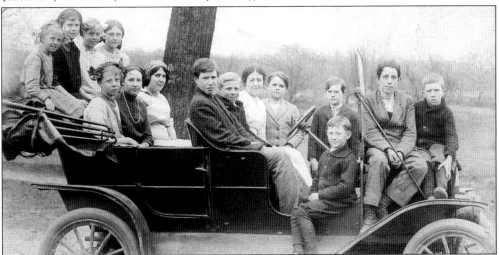

These are pupils of Fail School in the early 1900s. The school was located on the corner of present-day CR 300 North and Fail Rd. There is a marker at the site commemorating this school built by Philip Fail in 1870 and burned in 1971. Photographers offered these photos of "your school" throughout the county along with the prop in which they would be taken. Most of these pupils appear to enjoy the opportunity to have their picture taken.

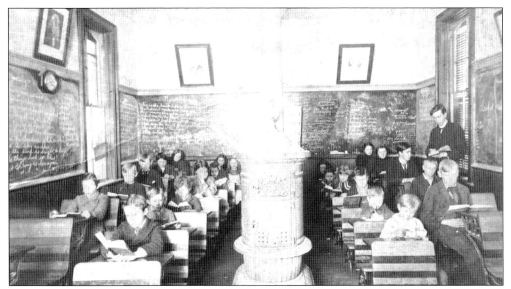

A one-room school is defined as a school with all grades, one through eight, being taught by one teacher and a curriculum which was very different from today. The heating system in this school is a wood stove and the teacher was primarily responsible for supplying the wood. Sometimes parents and students assisted, however. In this picture, the stove is in the center of the room but often they were located in other areas. By 1905-06, there were still 89 one-room schools in La Porte County.

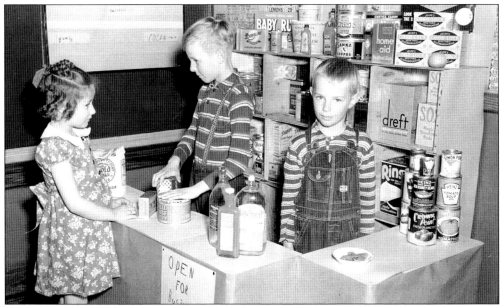

At the Stillwell School in Pleasant Township in 1940, this project by the social studies pupils gives them the firsthand experience of operating a grocery store. The "store" was constructed in a corner of the room from orange crates, empty cartons, cans, and advertisements. A study of numbers, reading, and spelling of simple words was correlated. Here we see Gael Swing waiting on Joan Miller while David Levendoski arranges the display. First and second grade teacher Miss Helen Lue Huhnke directed the project.

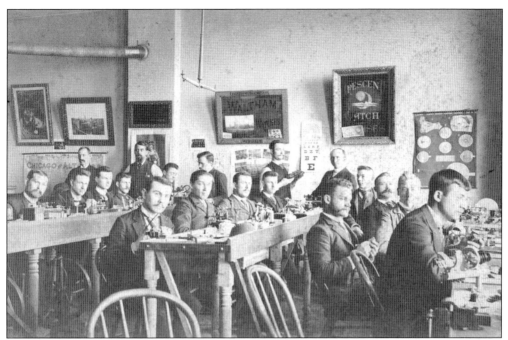

Hutchinson's Practical School of Watchmakers was founded in La Porte in about 1889 by John L. Hutchinson, Proprietor. It was first located on the second floor of the building at 912 Lincoln Way and from there moved into the Odd Fellows building, finally to the upper floor of the building at 712 Monroe St. The school won acclaim in the national press and from leading manufacturers of watches and clocks. It was discontinued in 1905 or 1906.

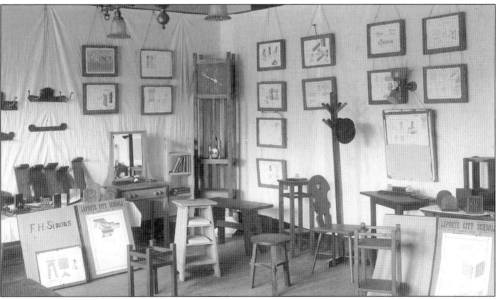

The year 1890 heralded the advent of Prof. Frederick H. Simons and the formation of a definite program for the development of art in the La Porte Public Schools. In 1904, his art department received a gold medal as first prize in the Louisiana World's Fair Art Exhibit. Henry E. Koch, a local photographer, captured a photograph of a display of creations by students of Prof. Simons.

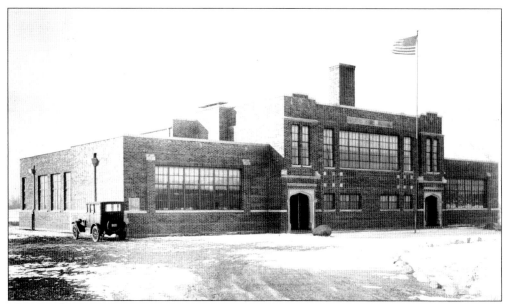

The new $51,000 Center Township School on Johnson Rd. was ready for occupancy on the first day of school in September 1927. George Goodall was the general contractor. Building this school eliminated the need to carry elementary students from this township to La Porte. Only high school students would now be transported. The red brick building, located on four acres of ground, stood well back from the road with a semi-circular drive from the road around the front and back of the school. In the rear is a large field which eventually would be utilized as an athletic field. There were a total of five classrooms, all very light and airy with slate blackboards.

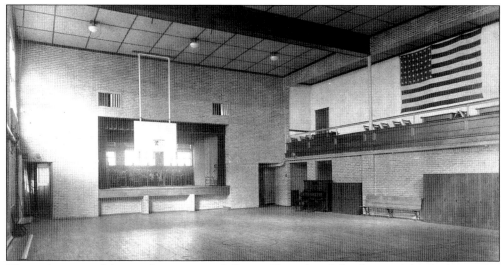

The auditorium of the newly-constructed Center Township School was 40 by 60 feet and it could seat more than 350 people. Additionally, the balcony could hold 50 people. On the west end was a stage to be used for theatricals and programs. The rear of the stage could be moved aside, exposing a classroom which made possible a much larger platform. The ceiling of this room (and the entire building) was made of wallboard which eliminated all echoes. The auditorium could be used for community affairs of all kinds as well as for games by the pupils.

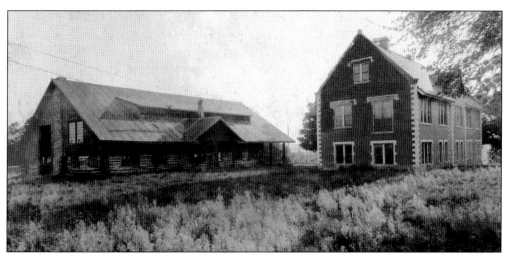

Located on Pine Lake Ave., where Waverly Rd. dead-ends from the west, the Interlaken School for boys from 7 to 18 years was opened in 1907. Dr. Edward A. Rumely had visited schools in Europe and was impressed with the great importance of their new approach toward education. This induced him to establish a similar institution in the United States. In 1911, the school (but not the buildings) was moved to a 1,000-acre tract near Rolling Prairie. When La Porte celebrated its centennial in 1932, some of the logs from the recreation hall and gymnasium were used to form the side wall of the pioneer cabin. The school building has been used for such activities as a skating rink, dance hall, tractor school, and antiques shop.

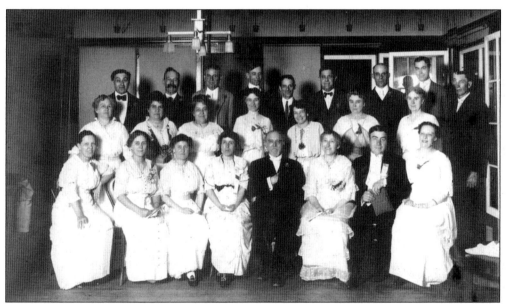

A reunion of La Porte High School's class of 1890 was held at the Bay Tree Inn in 1914. From left to right; (first row) Sophie Smith Warner, Beth Ericson Morse, Neva Line, Grace Ely Schafer, Dr. William Nicholas Hailmann (Superintendent of Schools), Alta Adkins, Albert Crawford, Sadie Whiting Hart; (second row) Sylvia Harding Huckins, Mary Rosenthal Brown, May Peters Alger, Nellie McFarlane Bryant, Edith Buck VanTrease, Grace Holloway Butterworth, Emma Fredrickson, Will Huckins; (third row) Ira Brown, John Warner, Ed N. Schafer, O. Dell Bryant, Edwin Morse, Nelson Butterworth, Robert Butterworth, George Hart.

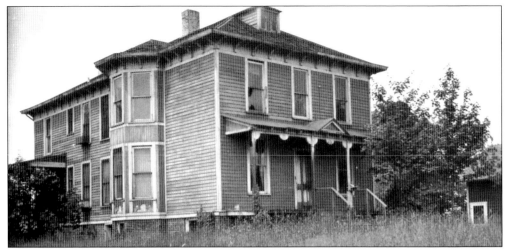

The Hawley-Hennessey Home School was located on the west side of Pine Lake Ave. on property that is now a part of the city's park system near the location of the gazebo. It was started shortly after the Chicago World's Fair of 1893 by John and Kate (Hawley) Hennessey in Englewood, Illinois. It was for children of parents who were traveling abroad or for some other reason could not care for their children. As it outgrew its quarters, it was moved to this house in La Porte around 1906. Children were instructed by the Hennesseys and other instructors until about the age of 12 when they were transferred to public school but continued to live here. The school was discontinued around 1910 and the house was razed in the early 1930s.

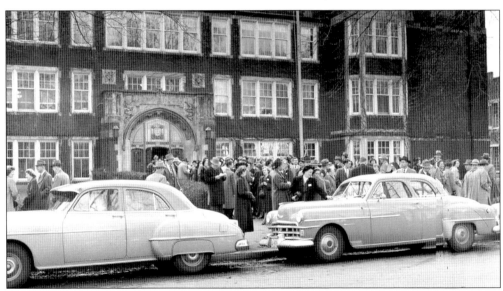

The architectural firm of Miller, Fullenwider, and Dowling of Chicago was chosen to prepare plans for La Porte's "new high school." In 1922, the contract was let to local contractor, Larson and Danielson for its construction on the south side of Harrison west of Madison Street. The total cost of the structure, which opened for the 1924-25 school year, was expected to exceed $500,000. It would accommodate 800 students, the gymnasium would seat 1,700, and the auditorium 1,200. The ornamentation of the entrance is representative of schools constructed during this time period. This particular photograph is of attendees at a Business and Industry Day program held at the school in 1951.

# *Three*

# HEALTH

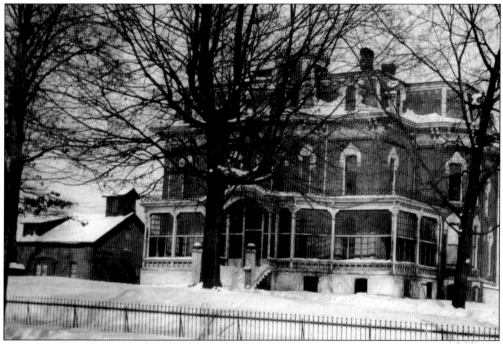

A large, elegant brick building located on Pine Lake Ave. in the approximate location of the present-day Kentucky Fried Chicken and 'Round The Clock Restaurants was erected by Dr. Samuel B. Collins as his residence. In 1868, he discovered medicine known as "Collins' Opium Antidote" and he used this building as a sanitarium for the treatment of opium patients. The dosage recommended was advertised as "sixty grains of morphine" on a daily basis; and after the first dose, "all desire for the drug instantly ceased." After his discovery, his business so increased, he erected a marble front store on East Main St. and started shipping some 40 cases of the antidote a day. The La Porte County Protestant Hospital Association was formed in 1924 and started seeking a location between La Porte and Michigan City to build a hospital. This idea was abandoned in 1926, and the Association purchased this building. It was completely remodeled along with the large brick building to the north which was later used as nurses' quarters and the heating plant. It was October 24, 1927 when the doors were opened to the public as Fairview Hospital. Records show there were 505 patients cared for in 1928, which included 234 operations and 88 births. The cost of caring for each patient was $4.10 per day.

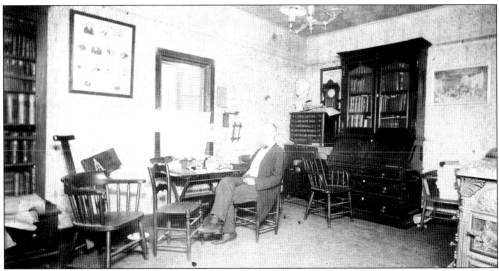

The office of Dr. George M. Dakin was located at a number of locations during the time he practiced medicine in La Porte. At the time of his death, December 20, 1911, his office was located at 707 Maple Ave. Born in Ohio, he studied medicine there while working on a farm and teaching school. He came to La Porte in 1862, where he took up the practice of Dr. Abraham Teegarden, who wished to retire. All the "tools of the trade" seem to be conveniently located in his comfortable office as well a reference library and, of course, a wood stove for heat.

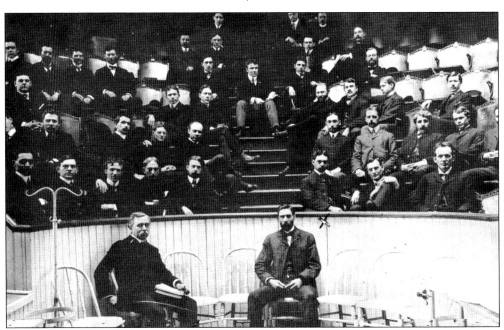

This was an amphitheater within the first medical school in Indiana and also the first such school west of Cincinnati, Ohio. La Porte University—Indiana Medical College was in existence from 1842 to 1852. This amphitheater was housed in a building on the corner of Clay and Walker Sts. It is believed that the Hon. John B. Niles was the person who, in all probability, conceived of the idea for the school. This may be the judge sitting in the front (ink cross by him). The school was to consist of literary, medical, and law departments.

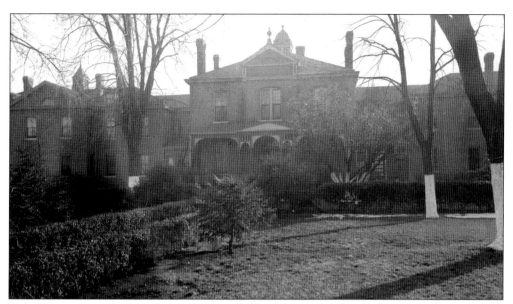

A bid was accepted May 14, 1886, from William J. Bower of Greencastle, Indiana, for the amount of $19,369 to erect the La Porte County Asylum (later to be called the La Porte County Home). The architect was a Mr. Chapman who also drew the plans for the La Porte City Hall. The building was to be located on 248 acres purchased at a cost of $20,000 from William B. Hammond and located in Scipio Township. Although many county homes have been closed, La Porte's continues to serve persons referred from many sources including doctors, hospitals, courts, and churches.

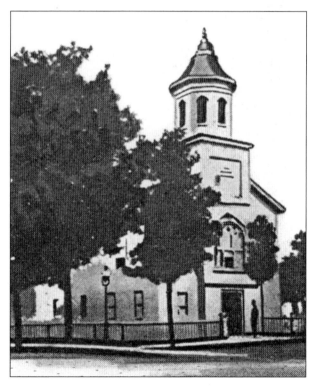

There is record of 18 graduates from the La Porte University – Indiana Medical College in 1845. The four-month term lasted only during the winter months, usually beginning the first of November and continuing until the latter part of February. The fee for the full course was $60; matriculation –$5; dissecting room – $5; and room and board from $1.50 to $2.00 per week. Before admission, the student was required to show evidence of having studied for a specified amount of time under the supervision of an established physician or "preceptor."

A native of La Porte, Dr. Eber L. Annis was named for his father, Eber Leander Annis. Dr. Annis was a physician and surgeon, having graduated from Rush Medical College in Chicago with the class of 1881. He started his practice in La Porte the same year; his office was located in what was known as the Higday Building in the Balcony Block (northeast corner of South Main and East Main). In 1914, he relocated to the Masonic Temple building.

In 1860, this building was built to be used as a hospital during the Civil War. Located at 102 C St., it has become a familiar landmark. It served the 9th Regiment in 1861, when that regiment, known as the "Bloody 9th," rendezvoused at Camp Colfax at the west edge of La Porte. It also served soldiers at Camp Jackson at the north edge of La Porte. The building is still in existence and is currently a family residence.

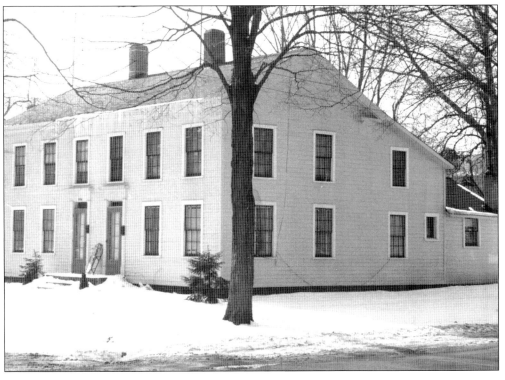

The young, "botanic" physician, Dr. Abraham Teegarden, born in Ohio in 1813, came to La Porte in 1837, where he spent the rest of his life. He died here in 1883. The first patient he was called upon to treat professionally in La Porte County was Robert White, of Door Village fame and also an early settler in the county. Their friendship endured as long as the doctor lived. Teegarden married Lura Treat and the house they built on Main St. contained offices and living rooms, as well as accommodations for students who were eager to profit by his instructions. The attic was devoted to skeletons and dissecting rooms.

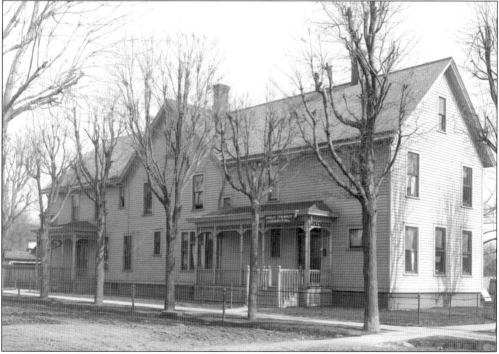

The white frame dwelling, located at Second and E Sts., was the Holy Family Hospital, under the direction of six sisters from the Ancilla Domini Order. When they came here in 1900, they said they intended to locate a general hospital in La Porte because such a facility was badly needed. Their first patient was admitted March 22, 1900 and it was six weeks before they had another. Before the close of the year 1900, they had cared for 72 patients (49 of them paying in full) and had moved their living quarters to the attic of the frame house so they could accommodate 12 patients at a time.

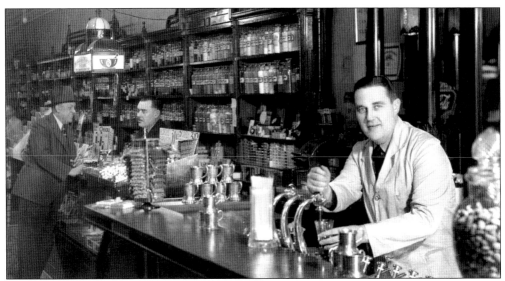

The name Meissner is synonymous with pharmacy in La Porte. Frederick W. Meissner, became interested in pharmacy and started his career in the Dr. E.E. Eliel pharmacy. The native La Portean later entered into a partnership known as Kuehne and Meissner. He sold out his interest and entered the Philadelphia College of Pharmacy. In 1888, he established his own drug store in La Porte at 820 Lincoln Way (across from the courthouse). His sons, who continued the business, are seen in this photograph; Roger is talking with a customer while Frederick (Fritz), is at the soda fountain (which was an important part of almost every pharmacy). He was also a member of the noted Maple City Four.

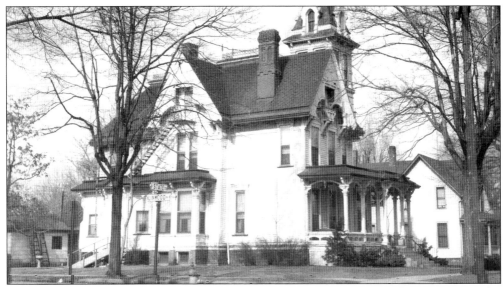

The residence at 209 State St., a neo-Jacobean architectural style, was built in 1879 for John H. Fildes of the King & Fildes Woolen Mills. In the late 1960s, it was acquired by the Salvation Army Corps. and was razed to make room for the present Salvation Army Corps., Community Center. Prior to this, the structure was the property of the White Tower Nursing Home. The 20-room landmark had been remodeled for the care, comfort, and safety of some of La Porte's senior citizen residents.

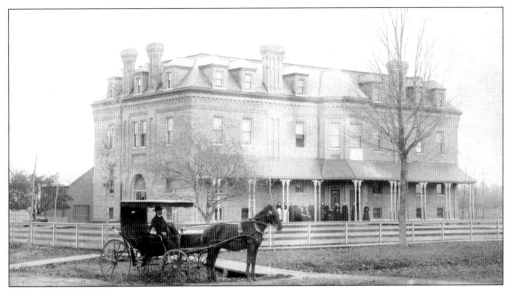

Founded in 1888 by Mrs. Ruth C. Sabin and opened on November 20, 1889, the Ruth C. Sabin Home for Elderly Women, at 1603 Michigan Ave., has continued to serve the purpose for which it was established. Ruth C. Clark was born in Massachusetts and married Sydney Smith Sabin in Groton, New York on April 4, 1832. They moved to La Porte County, settling in Noble Township and in 1870, relocated in La Porte. To carry out her plan for a comfortable home where women in their declining years might live, she gave $25,000 for the grounds and building, besides setting aside a fund to provide income to support the institution.

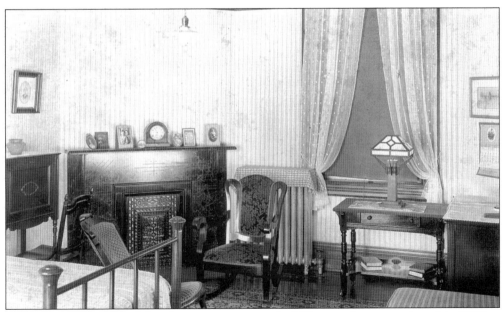

Originally, the Ruth C. Sabin home was comprised of 35 rooms but was enlarged in 1926 to 41. Typical apartments are as shown here. The rooms were all on the first two floors, with long, wide main halls and ample furnishings throughout. The matron and her assistants resided on the third floor. The building was heated with steam and lighted with electricity (note the radiator in this photograph). In recent years, it has been opened for male residents.

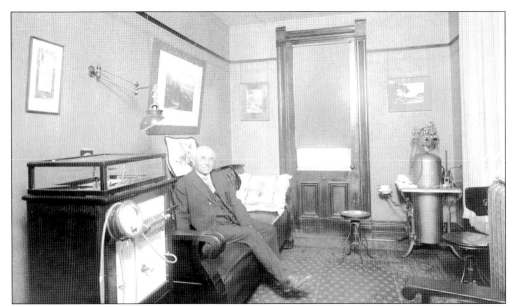

During most of his professional life in La Porte, Dr. J.H. William Meyer maintained an office at 704 Jefferson Ave. He was born in Germany in 1853 and came to the United States in 1871, at the age of 17, locating in La Porte. He graduated from Rush Medical College in Chicago in 1876, and entered the Cook County Hospital as an intern and studied eye and ear diseases. He came back to La Porte in 1877 and began his practice. He later studied in Europe and returned to La Porte to resume practice and lecture on the anatomy and diseases of the eye at the School of Watchmaking.

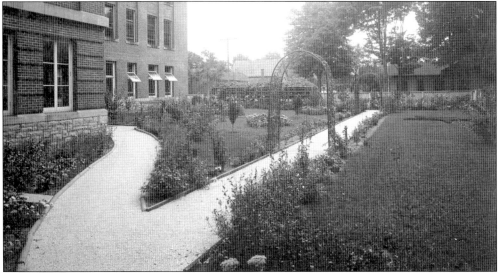

The convent at the Holy Family Hospital on E St. was erected in 1916 and the sisters' beautiful garden in front of the hospital at the E St. entrance added to the beauty of the facility. In 1925, more room was needed, so a large addition was built and it was necessary for the sisters to give up the park-like garden with its borders of flowers and pleasant walks. La Porte Hospital was constructed in 1972 and in 1981 the E Street Hospital building was razed. Residences are now located on this site.

# *Four*

# STREET SCENES

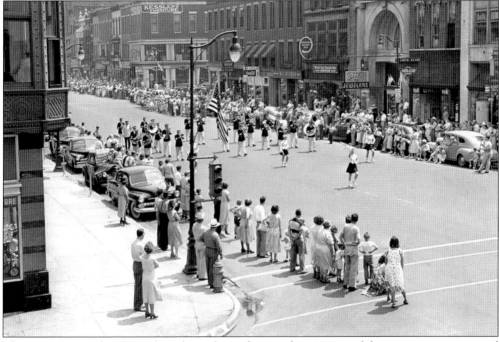

The main street of La Porte has always been the parade route to celebrate various events and holidays. This 4th of July Parade in the 1940s is just one held to commemorate the adoption by the Continental Congress on July 4, 1776, of the Declaration of Independence. The Jaycees of La Porte have been the sponsors of this event since 1946. Throughout the years, the parade marshals, grand and honorary, have been from the political arena, local and otherwise, as well as local and other "celebrities." It has become a tradition to have a fly-over preceding the start of the parade. These have included many types of airplanes and the crowd always awaits this event with great anticipation. The Governor of Indiana proclaims La Porte as the "Capital of Indiana" for the day of the parade. In this photograph, one of the many bands is seen heading west down the block between Indiana Ave. and Madison St. The number of units in the parade varies from year to year. The crowds "stake out" their locations prior to parade's start time. This day would appear to have been a bright and warm day with a large crowd attending to enjoy it. Parking was allowed on the parade route at this time and parking meters lined the street. This block of Lincoln Way has changed immensely since this time.

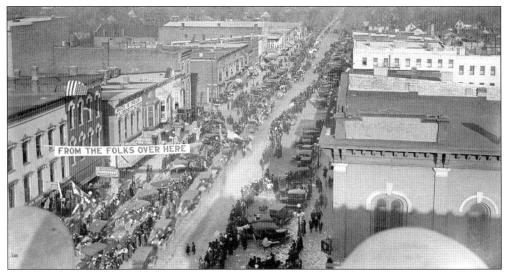

Looking east from the First National Bank building on the corner of Michigan Ave. and Lincoln Way, we see the Armistice Day Parade of 1918 in progress. The banner across the street reads "From the Folks Over Here." Not seen in this picture was a banner visible as one looked west from the same location which read "Send the Home to Him." Numerous cars can be seen at a great distance to the east and this was true also in the other direction. Some of the signs noted on the businesses include Buck & Heusi Furniture, Etropal Theater, Sonneborn's, and Candy Kitchen.

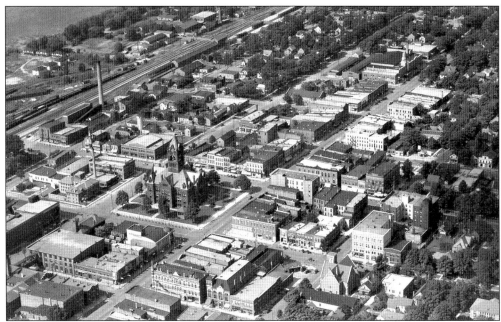

A bird's eye view of the downtown area of La Porte is seen here and the courthouse square is to the left of the center of the photograph. This is an undated photograph but we can see there are a number of smokestacks still in place which have not been in existence for many years. The Masonic Temple building was erected in 1913, and it, along with a number of other structures, are clearly identifiable, including the Hotel Lincoln and the La Porte Theater.

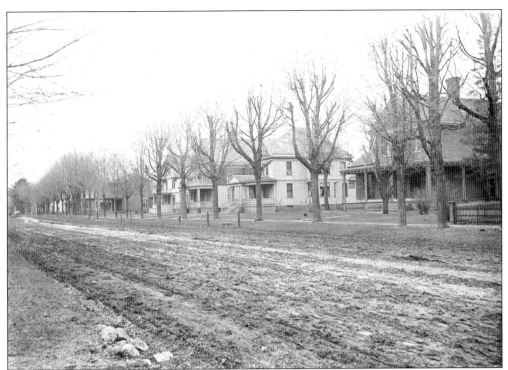

In 1885, none of the streets of La Porte were paved and this can be attested to by this view of Indiana Ave. at that time. This is looking south towards Alexander Street. When the rain and snow came, it was very difficult to get around with the horse-drawn vehicles.

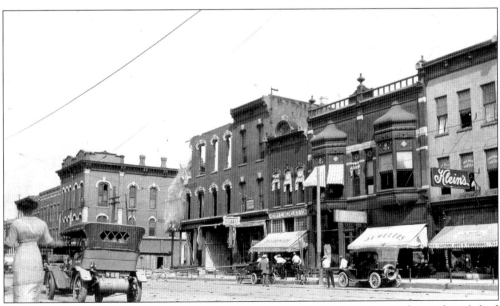

The building on the southwest corner of Lincoln Way and Michigan Ave. is being demolished in 1914 to make room for the First National Bank Building to be constructed. This building was known as the Scott Building. It was in this building that a meeting was held on January 30, 1906 in the office of William Niles for the purpose of organizing a county historical association.

James Stuck is seen here trimming the street lights. His horse, with a two-wheeled cart behind, waits patiently while he performs this task at the corner of Michigan and Maple Ave. in 1908 for the La Porte VanDepoele Electric Light Company. The company was incorporated in 1884 and their plant was located on the south side of Front St. (where railroad tracks were later laid), between Monroe St. and Michigan Ave.

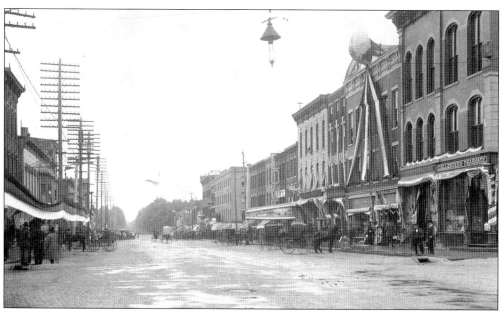

The George H. Terpany Tent #25 of the Maccabees, a fraternal and benevolent legal reserve society, was organized in 1889 in La Porte. The Maccabee Hall was located upstairs in the building at 718-720 Main St. (Lincoln Way) on the south side of the street between Michigan Ave. and Monroe St. They held The Maccabee Great Camp Review Day in La Porte on May 22, 1901. In celebration of the event, streamers adorn the front of this building. This is a view of the area looking east from the corner of Michigan Ave.

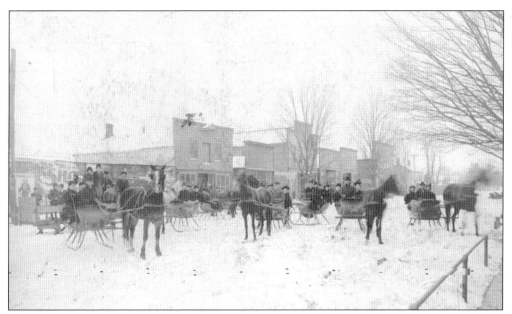

It looks like they are getting ready for a sleighing party. This is a typical street scene in a winter in La Porte. Sleighing was an avid pastime for many residents. Many times groups would gather and travel "all the way" to Michigan City to enjoy the winter weather and meet with friends in the neighboring community.

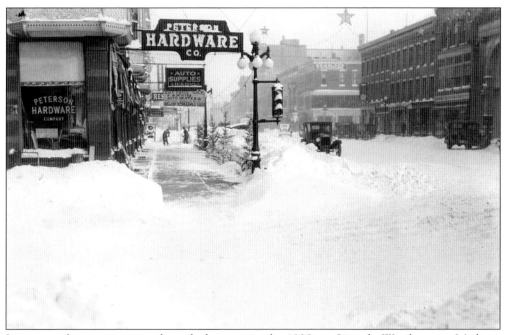

It was not always easy to get through the snow in the 1920s on Lincoln Way between Madison St. and Indiana Ave. Manual labor was the solution to clearing the sidewalks, as seen here. The Christmas decorations are in place as the trees line the street and the stars hang overhead to help herald in the holiday time of year. One of the Arvin Auto Heaters, advertised on the sign at the auto supply store, would have probably been a good purchase.

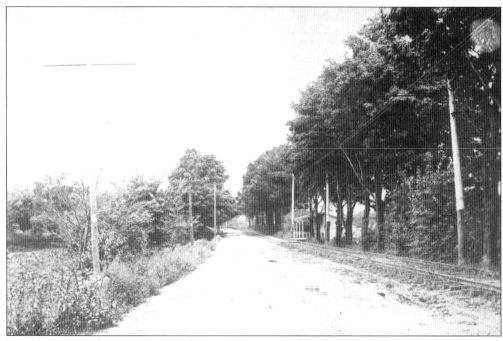

In 1903, Pine Lake Ave. was a rather narrow, unpaved road but it was the beginning of the link between La Porte and Michigan City. The interurban line ran parallel to Pine Lake Ave., however, there was about a 2.5 mile gap between the line from La Porte and the one from Michigan City. The gap was closed mid-January and a train, with dignitaries aboard, left La Porte, Saturday January 31, 1903 at 3:47 p.m. and arrived in Michigan City at 5:20 p.m.

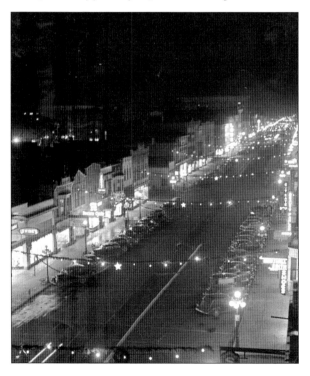

Looking west on Lincoln Way from the corner of Jackson St., there would appear to be a parade prior to the Christmas period and decorations above the street would indicate it is "that time of year." Flag bearers are in the foreground with quite a distance between them and the other participants. The many cars parked along the thoroughfare might indicate a large number of people are waiting to enjoy the parade, keeping warm and protected from the elements inside their cars. The well-lighted stores could also indicate that they were open for that last-minute shopping.

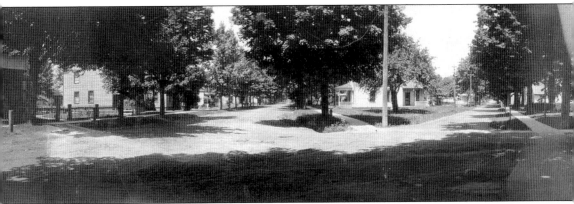

The streets in La Porte do not always follow the path one would logically assume they should. This is an example of such a situation where Rose and Clay Sts., which both generally run in a north-south direction, come together at a south point. Rose St. continues a short distance to dead-end at Monroe St. (which, by the way, is also a north-south street, curving southeast just before Rose St. reaches it).

One of the busier corners in downtown La Porte, showing the east side of Michigan Ave. between Lincoln Way and Jefferson Aves. This was called the Barnes Block in the late 1880s. The building, across Lincoln Way to the north, on the northeast corner, was called the Balcony Block because it had a very fine wrought iron balcony across the front at the second floor level.

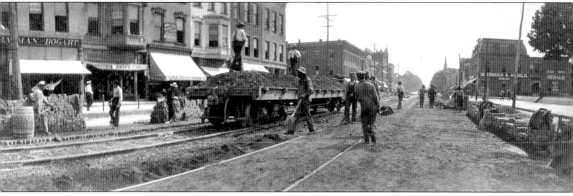

Looking west on South Main St. (Lincoln Way), workers on the block of the courthouse are laying brick for the new pavement of the street. In the early 1900s, brick was laid on many of the streets, replacing the old blocks. Brick making is recorded as being one of the very early industries in the area and bricks were readily available from the brickyards in close proximity to La Porte.

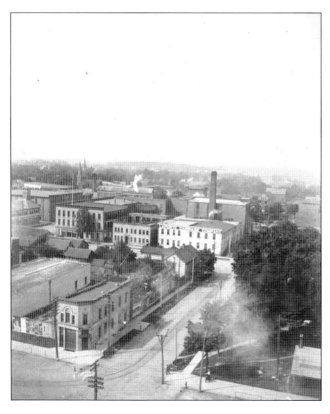

In the foreground and looking west we see the location of the current La Porte County Complex and Jail at the corner of Michigan Ave. and Washington Sts. At the time of this photograph, a "saloon" occupied the corner building. The block to the west, where the La Porte Carriage Company was located, is now the location of the overpass. The Central Fire Station (built in 1907) can be seen in the middle at the left of the photograph. Note the interurban tracks, the initial part of the job which was to build a "loop" running down Main St. (Lincoln Way) from Michigan Ave. to Madison St., north to Washington St., east to Michigan Ave. and then back to the starting point.

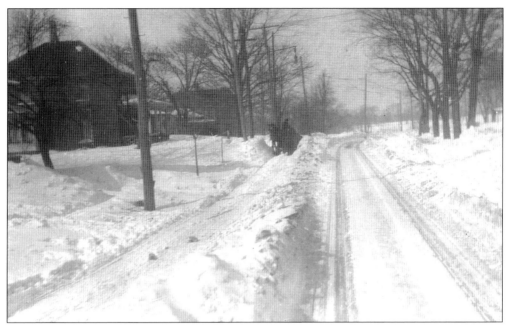

The view in this photograph of Pine Lake Ave. is as seen through the eyes of the motorman of the interurban train. During the winter of 1918, it would appear that at this point heading northwest from Wardner St., only the train tracks were passable.

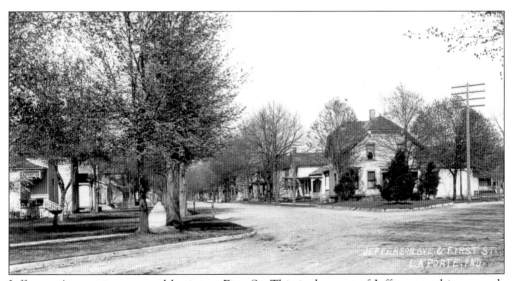

Jefferson Ave. at its west end begins at First St. This is the start of Jefferson and it proceeds at an angle to the east while First St. goes directly east. This is still a residential area but the automobile has replaced the need for the hitching posts seen here.

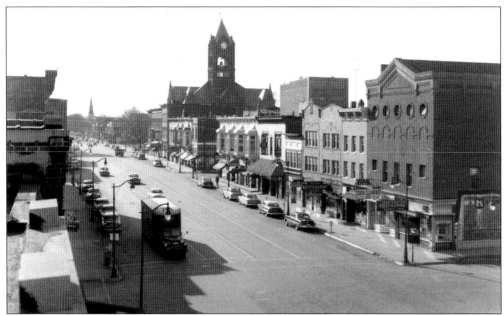

This photograph shows the main street of La Porte, Lincoln Way, looking west from Clay St. during the time when parking meters were in place. One had a choice of restaurants, retail stores, and, at this time, there were four theaters. The Fox Theater was on this block. The Roxy can be seen in the distance at the northwest corner of Indiana and Lincoln Way.

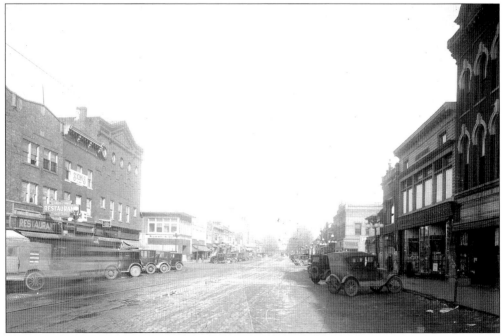

Before parking meters, and in a much earlier time than the above photo, this view to the east of the main street (Lincoln Way) is from mid-block between Monroe and Clay Sts. On the south side of the street are such stores as the Serve Yourself Shoe Store, F.W. Woolworth 5 and 10 Cent Store, and Albert J. Stahl's Bank.

# *Five*
# CHURCHES

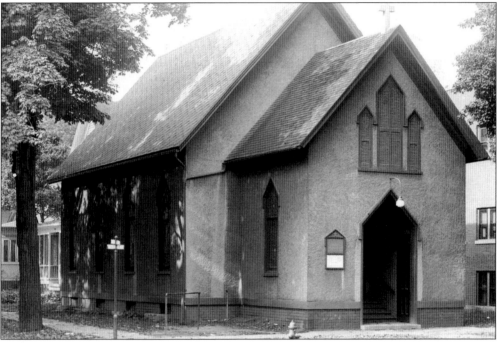

In 1859, The Society of the New Church in La Porte was organized on the northwest corner of West Main and Prairie (now Indiana and Maple Aves.). On July 7 of that year, the lot for the church was transferred to the Trustees by James Andrew and his wife "for the purpose of erecting and maintaining a building for religious worship." The price was $500 and Mr. Andrew donated this as his share of the undertaking. Mr. Sebastian Lay gave the timbers while others gave materials, labor, and monetary contributions of as much as $500. The building was dedicated on Sunday, September 11, 1859 and services were conducted by the Rev. Henry Weller. The formal organization of the Society in 1859, however, was not the beginning of the New Church in La Porte. Rev. George Field states in his book, *The Early History of the New Church in the Western States and Canada*, that he "arrived in La Porte March 14, 1842," where he gave two public lectures in the courthouse, one on the Trinity and one on the Atonement. This church was also known as the Church of the New Jerusalem or Swedenborgian Church. The original building was of Gothic architecture but during the pastorate of Rev. Frank A. Gustafson (1908-11), the church was raised, stuccoed, and modern heating and plumbing was installed along with other modifications.

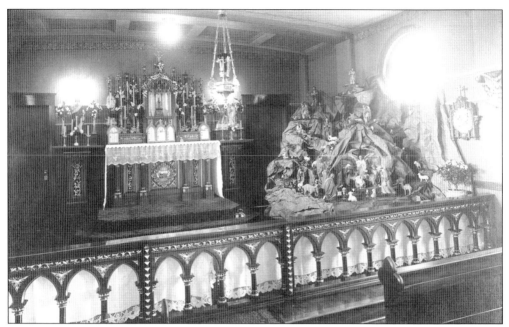

The addition to Holy Family Hospital in 1915 included a chapel. Physical care of the patients was the responsibility of 13 Sisters under the direction of Sister Helena, the Sister Superior. Rev. Godfrey Schlacter, the first Chaplain, assisted with the spiritual needs of patients in the newly-constructed chapel. It was located on the second floor of the hospital where it could be reached by a passageway leading through a pair of beautiful stained glass doors.

Around 1918, this group of young people posed for their confirmation at St. John's Lutheran Church. The young men, in their best suits with boutonnieres, and the young ladies, adorned with corsages in dresses that would possibly be handed down to future generations for a similar event, are seen here carrying their Bibles for this important day in their lives.

This Baptist Church was located on the west side of Jackson St. and Prairie (now Maple) Ave. In 1857, it was announced that the Baptists would build a new church at this location. It was in use by the fall of 1858.

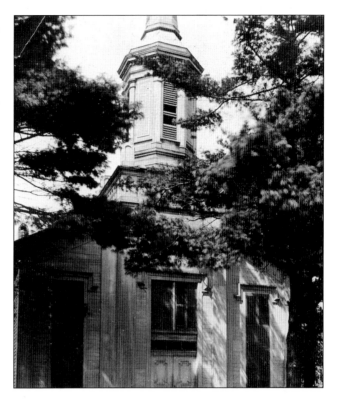

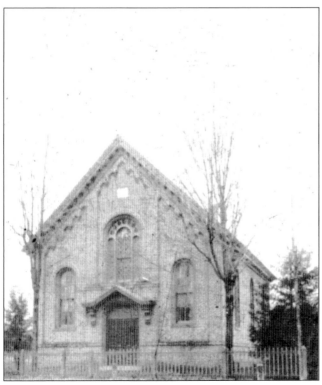

This is the only photograph known to be in existence of the Jewish Synagogue of the B'ne Zion Congregation of La Porte. The temple was located on the northwest corner of Indiana Ave. and First St. and was dedicated on February 28, 1869. Reportedly, because of the lack of interest and response from the membership, an agreement was reached on October 30, 1898, to sell the property, after which the temple was dismantled and the bricks were used for other purposes.

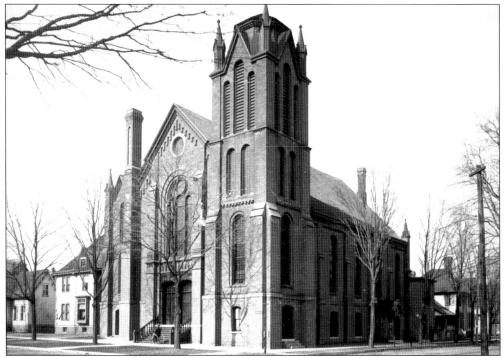

The property at the northeast corner of Noble St. and Michigan Ave. was purchased in 1868 for the erection of the Second Presbyterian Church. Ground was broken in August of 1869 and the cornerstone was laid on the 18th of October of that year. The pastor at the time was Rev. Wm. C. Scofield. The seating capacity was 677 and the cost of the building was approximately $30,000; $11,000 was borrowed to complete it. It was replaced with a new church on Kingsbury Ave. in 1964.

From 1871 to 1889, Rev. John F. Kendall, D.D. served the congregation of the Presbyterian Church. It was reported that during his pastorate, "relations between pastor and people" were the most "cordial, harmonious, and of affectionate character." He was a very community-minded person and served on the Board of School Trustees, 1876-77.

St. John's Evangelical Lutheran Church was organized on July 19, 1857, and was located on the northwest corner of A and Third Sts. The congregation was made up of the German Lutherans of La Porte. It was used until 1954. It is currently occupied by the La Porte Little Theatre group for their presentations.

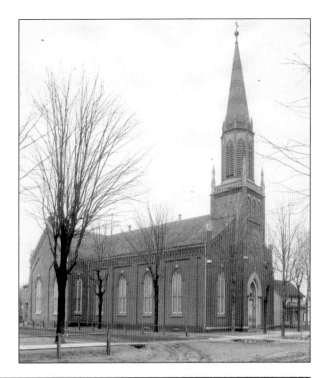

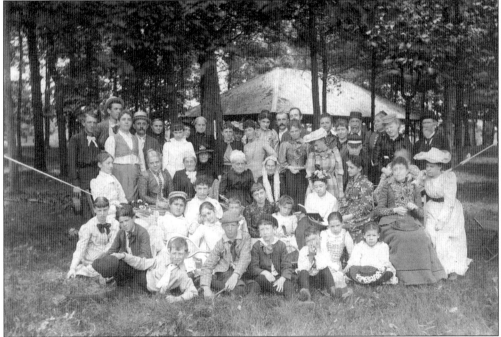

Weller's Grove was owned by the Weller family and was the resort of many Swedenborgian Church families who came from near and far to enjoy the grove. The Assembly here was unique, being the only New Church gathering of this character in the world. The Assembly was held at these grounds, located on Stone Lake. William H. Weller and his wife would host visiting clergymen without charge.

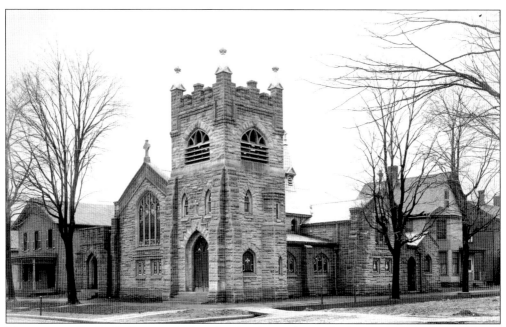

This present St. Paul's Episcopal Church of gothic-style was built in 1897, on the southwest corner of Michigan Ave. and Harrison St. The first church was erected in 1846. During the tenure of Dr. Solon W. Manney, who arrived in 1840, property on the southeast corner of Indiana and Maple Aves. had initially been purchased as a church site but was exchanged for this location for "fifty dollars, half in cash and the balance in hewn timbers suitable for the church frame." That church was enlarged in 1869 by the addition of transepts and the lengthening of the nave. It was used until the erection of this building.

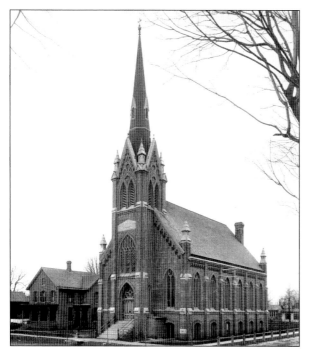

Built in 1883, the Bethany Lutheran Church (Swedish Lutheran) is located on the southwest corner of First and G Sts. A church bell was presented to the congregation in 1890 by the Young People's Society. The first pipe organ was installed in 1893 at a cost of $1,800.

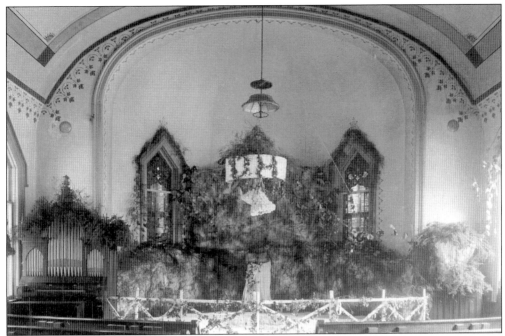

An interior look at the New Church (Swedenborgian) built in 1859 on the northwest corner of Indiana and Maple Aves. Originally, much use was made of ornamentation by painting rather than carving. Later memorial windows were placed on the sides and in the chancel.

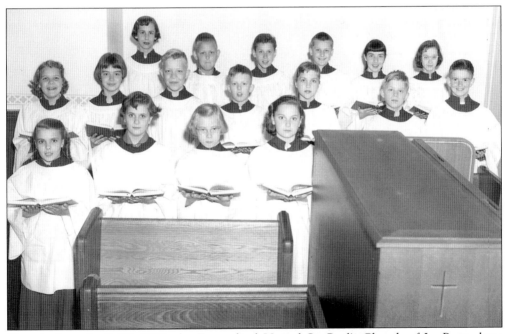

Organized on April 30, 1867, the Evangelical United St. Paul's Church of La Porte, later St. Paul's Evangelical and Reformed Church, and today known as St. Paul's United Church of Christ, is located at the northwest corner of Lincoln Way and the now vacated Perry St. Members of the youth choir are seen here singing at one of the services.

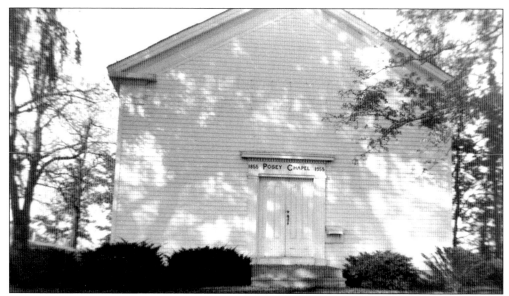

Throughout La Porte County were many small churches of various denominations. Some are still being used today. This Posey Chapel (Methodist) was erected in 1855 and the funeral of Mary Goit was the first service held here. There had been a log church on this site previously which was also named Posey Chapel in honor of the founder, Wade Posey. The first burial in the cemetery, located beside the chapel, was George Morrow, on July 14, 1845. The chapel which stood on the north side of present-day CR 1000 North, was destroyed in 1972 by an arson fire set by vandals.

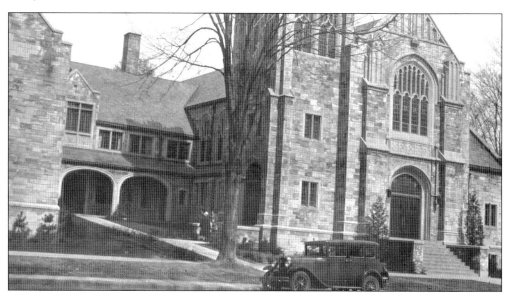

The cornerstone for the First Methodist Episcopal Church was placed on October 9, 1927 on the northeast corner of Michigan Ave. and Alexander St. This structure has perhaps one of La Porte's most impressive facades on Michigan Ave., an example of 20th century Gothic Revival architecture. The architect was George Wood Allen, a prominent local architect responsible for many structures not only in La Porte but in nearby towns and cities. This is now the First United Methodist Church.

In 1877, the congregation of the Baptist Church authorized the purchase of the Andrew property on the southwest corner of Indiana and Jefferson Aves. at a cost of $4,500, for the purpose of building a new church, estimated to cost $13,000. This building was dedicated on October 20, 1878. Folant and Evory were the contractors.

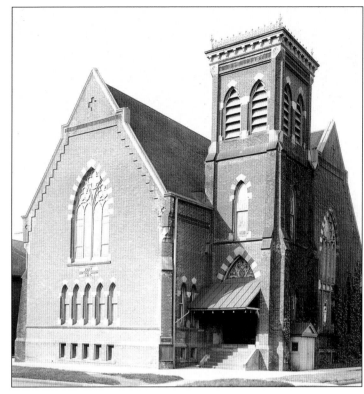

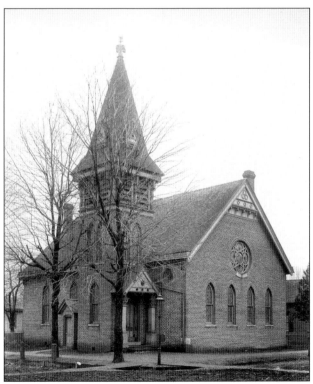

When Rev. Morf was pastor of the German Methodist Church, this brick church was built on the southwest corner of Harrison and Clay Sts. The cornerstone was laid on Sunday, May 25, 1884, with the usual exercises on such occasions. The church was used until the congregation united with the First Methodist Church in 1919. This building has been used for various activities since then and is still in existence.

Located on the southeast corner of Alexander and A Sts. was the early Quaker or Friends Meeting House. In 1869, the Hicksites and Orthodox groups joined together, on what was their cemetery grounds, to erect this brick house of worship which required 66,000 bricks. The building was 32 feet by 45 feet and had an 18-foot ceiling, with a seating capacity of nearly 400 people. The original cost was $4,000. It has now been converted into apartments.

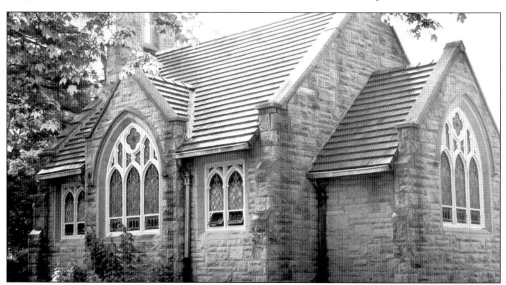

The beauty of the Eason Memorial Chapel, which stands on Chapel Hill in Pine Lake Cemetery, lies in the simple and beautiful lines of its English Gothic design. The plans for the chapel were prepared by Architects Allen & Sons and the building was erected by Larson-Danielson Construction Co., a local contracting firm. It is made from Bedford, Indiana oolitic limestone and is a 48.5 feet by 25 feet with a cross at the top of the tower 37 feet from the ground line. It was dedicated on December 9, 1912, in memory of Seth Eason, an early settler, member of the Hall, Weaver & Co. Bank, and President of The Pine Lake Cemetery Board of Trustees. It may be used by lot owners for memorial services.

*Six*

# GOVERNMENT

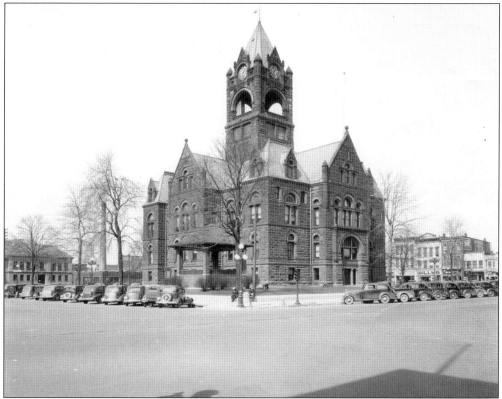

Three courthouses have been built on the public square in La Porte, the county seat of La Porte County. The first was built in 1834, the cornerstone for the second was laid in 1848, and the cornerstone for the third and present La Porte County Circuit Courthouse was placed on June 30, 1892, containing 120 items of history. Charles A. Moses of Chicago was the contractor and the architect was Brentwood S. Tolan. It is constructed of Lake Superior Portage Entry Red Sandstone which was selected at a cost of $197,244. It is included in the 1970 Historic American Buildings Survey. At the time this photograph was taken, there was a public drinking fountain on the corner of the sidewalk. The bandstand was located on the courthouse lawn as was a cannon and a pile of cannon balls which were later disposed of for scrap metal use during WWII. People found a place to rest on the concrete wall which separated the sidewalk from the lawn.

On the southeast corner of Michigan and Jefferson Aves., before the post office was built in 1912 (now La Porte City Hall), stood this green frame office of Dr. George Dakin. He is remembered as being a venerable, tall, thin, long-grey-bearded, kindly gentleman. On the shelves in his office were seen strange, dark-looking bottles, and some were thought to contain a mixture called nux vomica, which was a strychnine-containing seed.

On the north side of State St. across from the La Porte County Circuit Court House was the County Power House built of brick in 1916 at a cost of $16,200. The location was the site of the third jail, built in 1857, which was removed to make room for this building. Equipment installed in this building supplied heat and light to the "new" county jail, which was located to the west of the facility. The smokestack was a hexagon shape and stood nearly 60 feet high. It was one of the many smokestacks in place during the late 1800s and early 1900s.

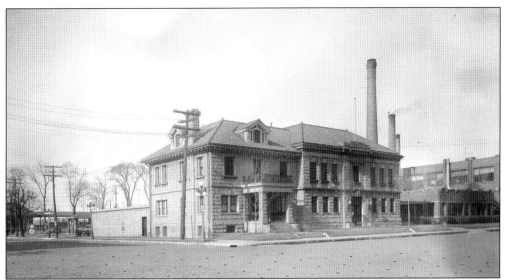

In 1908, the fourth La Porte County Jail was built on the northeast corner of State St. and Indiana Ave. It was constructed of Indiana limestone and Foltz & Parker of Indianapolis were the architects. The plans also provided for the construction of residence apartments suitable for the sheriff and his family. It served the county until 1976 when it was demolished and a new La Porte County complex and jail replaced it. The 1976 structure is now in the process of being remodeled and will include an addition.

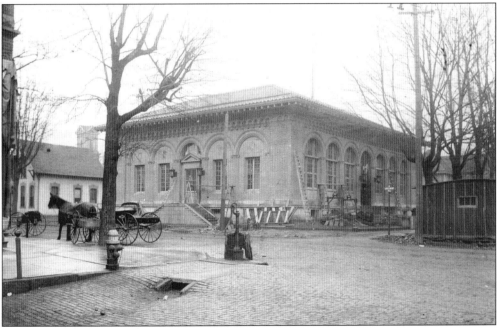

The new post office or federal building was built on the southeast corner of Michigan and Jefferson Aves. in 1912. Twenty-five people were employed then and served a population of 10,000. The Italian Renaissance style building was designed by James Knox Taylor of Washington D.C. The contractor was W.D. Lovell of Minneapolis, Minnesota and the cost was reported to be $56,000. Today the building serves at La Porte's City Hall.

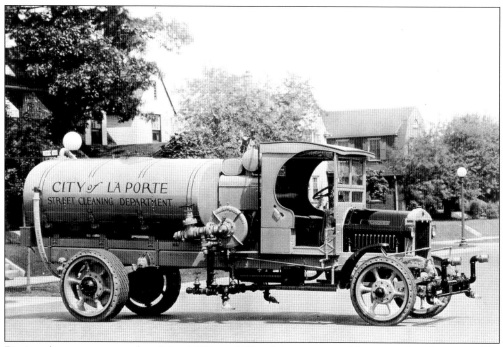

During the summer months of the 1920s and 30s, this street sprinkler, owned and operated by the City of La Porte Street Cleaning Department, was in demand throughout the city. In fact, the "better" neighborhoods vied for the frequency of trips by the sprinkler. Before the advent of paving and air conditioning, dust was a problem in housekeeping in the summer.

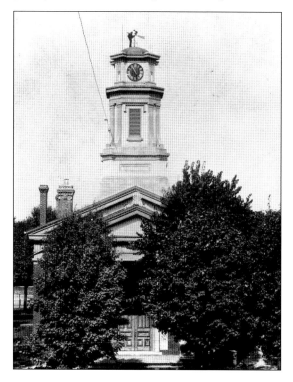

In 1847, the commissioners contracted for the construction of the second courthouse. The cornerstone was laid in 1848, and the building was completed in 1849. The architect was J.M. Vanosdel. L. Mann Jr. was contractor and A. Ballard was carpenter and joiner. This structure was truly a "courthouse" with a building on the west side housing the auditor and treasurer and one on the east side housing the sheriff, clerk, and recorder.

The La Porte Library and Natural History Association purchased property on the north side of Prairie St. (Maple Ave.) between Michigan and Indiana Aves. from the Place family on May 5, 1876. By the end of the month, plans and specifications for the new library building were completed. The plan was for a structure 24 feet by 70 feet with 15 windows and a main library room 22.5 feet by 55 feet. When completed, it was to be "in all respects, a good library home." It was ready for occupation in February 1877.

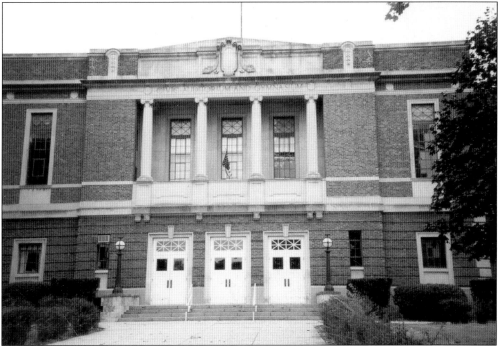

Built in 1929, on the east side of Ridge St., the Civic Auditorium was a gift to the City of La Porte by Maurice Fox as a memorial to his parents, Samuel and Fannie Fox. It encompasses an entire block, bounded on the north by Plain St., on the east by Woodward, and on the south by Tecumseh. It is of French Renaissance style architecture and John J. Davey was the architect and Neiler, Rich, & Co. were the engineers. Dedication of the building was held on March 19, 1930, having been postponed from the originally scheduled date of March 7 due to the death of Mr. Fox which occurred on February 24.

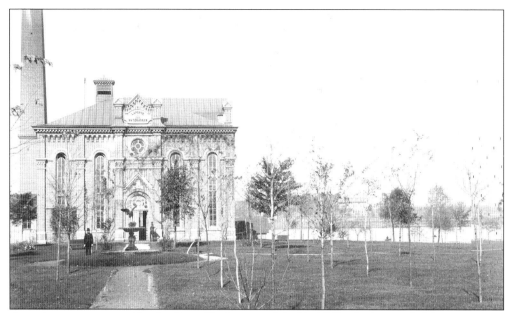

An ordinance was passed by the City of La Porte on July 23, 1870, which provided for a city water works. In that year, the La Porte Water Works Building was built on the banks of Lily Lake. The engine, known as the Holly System, which had the capability to raise five million gallons of water in 24 hours, was installed by George H. Storey. He continued as superintendent until his death. The brickwork was done by Alexander Hunt, contractor. This system remained as established until 1896, when new machinery, made by the Nordberg Mfg. Co. of Milwaukee was installed.

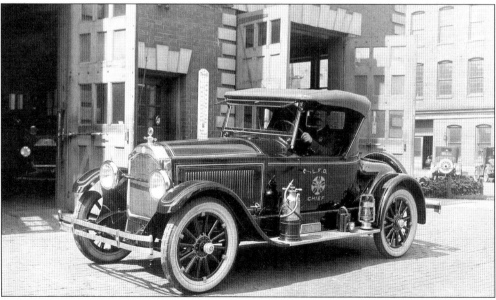

La Porte's Central Fire Station was located on the west side of Indiana Ave. between Lincoln Way and State St. Thomas Alexander Whorwell served on the fire department for 52 years and was chief for 39 consecutive years. In 1917, this "motorized car" was purchased from the Studebaker Corporation for the fire chief and he is seen here proudly driving the vehicle. Prior to this time, transportation to fires was provided by a "one horse power" buggy.

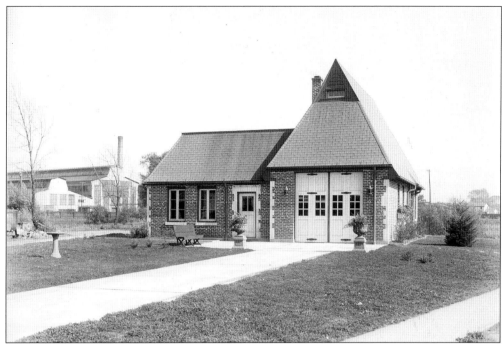

The new North Side Fire Station of La Porte, located on Pine Lake Ave. at Truesdell Ave., was officially put into operation on June 30, 1929. The architect was Arthur C. Steigely and Joseph Goodall was the contractor. Built of red brick, it has a colonial design with a sharp, gabled, steep roof. The station housed a 400-gallon American-LaFrance pumper formerly stationed at the Central Fire Station. At the time of its opening, a new 1,000-gallon Seagrave pumper had arrived and was to be unloaded and made operative soon.

In 1896, the La Porte Library and Natural History Association donated the library to the City of La Porte. Much remodeling was done including increasing the frontage to almost 70 feet. Greeting the public from behind the circular counter is Miss Emily Vail, who was the second Librarian. On either side of the counter were massive white walnut pillars which rose to the ceiling. Behind the counter were approximately 8,000 volumes for the public to read. A reading room was provided with easy chairs and tables and the librarian's apartment was at the far end.

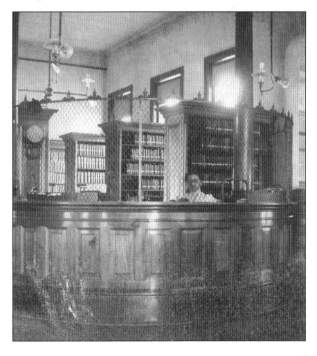

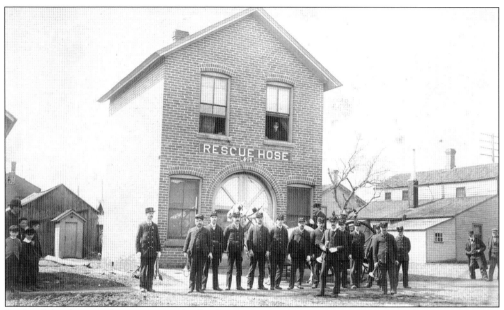

Each of the five wards in La Porte had a fire company. Rescue Hose Company #1 was located at 610 Jackson St. This house was believed to have been erected in the 1850s and was the first hose house in La Porte. Each house had a name such as Alert Hose Co., Dread Naught Hose Co., Rough & Ready Hook and Ladder, and the Wide Awakes. These companies not only drew attention to themselves for their service as volunteer firemen but also for their social activities.

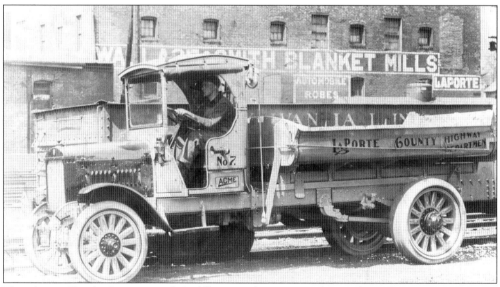

The Acme Truck Company of Cadillac, Michigan manufactured trucks such as this one during the period around 1915 through the early 1920s. One of the La Porte County Highway Department's trucks made by this company passes by the Wallace & Smith Blanket Mills which was located on Park St. near the railroad tracks. The mills supplied blankets to the U.S. Armed Services during WWI and shortly thereafter went out of business. Kingsley Furniture began production in this building in 1926 and, in 2001, announced discontinuance of the business and the building was demolished.

In the early 1940s, the City of La Porte purchased a Peter Pirsch aerial ladder truck, built in Kenosha, Wisconsin, which is seen here on State St. at the north side of the Central Fire Station. A demonstration of the 65-foot ladder is being made for some of the city's dignitaries. Fire Chief Albert E. Homann is standing on the truck while Assistant Chief Elmer Gladfke stands beside the truck.

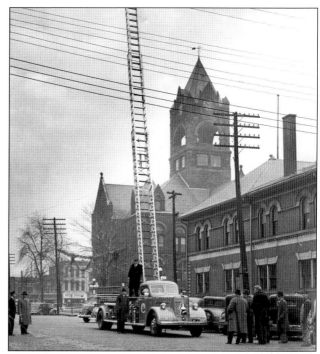

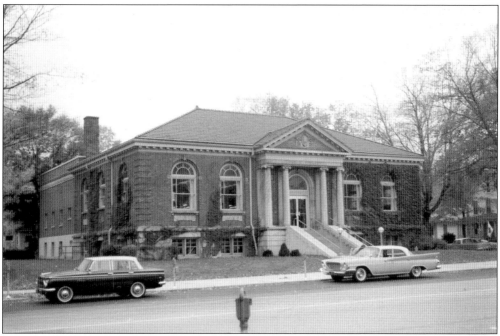

The City of La Porte entered into an agreement with Frank T. and Anna Roberts on April 11, 1916 for the purchase of the property located on the southwest corner of Indiana and Maple Aves. as a site for a new La Porte City Library. In 1919, a contract was let with Griewank Bros. for its construction. It was absolutely necessary that the building be paid for with the donation made by the Carnegie Corporation. Wilson B. Parker was chosen as architect. The facility opened unceremoniously on Saturday, November 6, 1920.

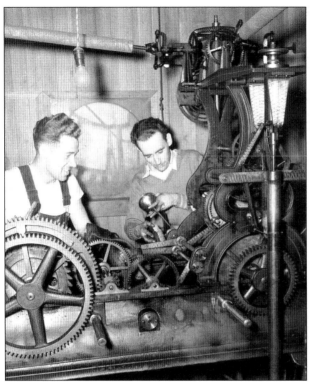

The clock in the La Porte County Courthouse tower required winding only once a week. To reach the clock, it was necessary to climb the spiral stairs from the third floor through a network of stairs through the attic to the tower, through three different doors, each needing to be unlocked, and a fourth into the belfry. Here the clock mechanism is being lubricated by Tom Rauschenbach and John Fitzgerald. In 1999, the clock underwent a major overhaul and it is thought that the same time will be on all four faces of the clock for at least the next 50 years.

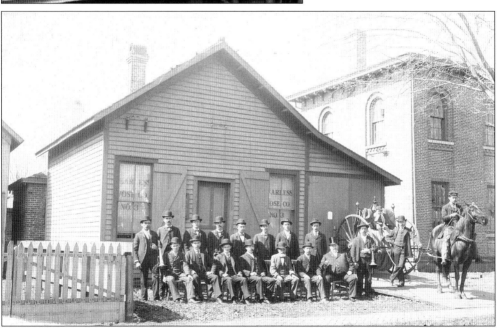

The Fearless Hose Co. No. 3 was located on Jackson St. between Walker and Clayton Sts. La Porte Hose No. 3 was organized in 1871. The department for each ward had different colored uniforms. This unit was dressed in a red, loose fitting shirt, black pants, red leather navy caps with a white band, and the unit's name on a silver shield. They also had black belts with "La Porte" in black letters on white ground.

A handsome fireplace, with mantle attachments and a large cut glass mirror set the reading room off in the La Porte City Library to excellent advantage. The room was finished in white walnut as were all the rooms throughout the building. The walls on the main floor were tinted olive green. The west wing was exclusively for the children. There were two large rooms upstairs, one to be used for board and literary society meetings and the other to display natural history specimens. This building, located at 805 Maple Ave., was used as a library from 1897 until the Carnegie Library was opened in 1920.

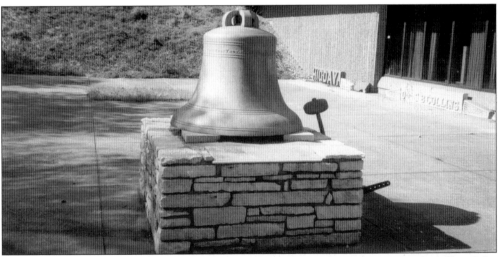

Atop the second courthouse was a 56-foot tower. The lower tower story contained a bell and the top story a clock. It was started in 1847 and was completed two years later. The initial cost of the bell was $500. It was first rung to announce the opening of the circuit court. It was also used for other events such as to summon the bucket brigades in case of fires. It was rung continuously to call the news that Fort Sumter had been fired on during the Civil War, and when Lincoln was shot and his funeral train passed through the county. In addition to the courthouse, it has been located in the old City Hall, atop the Central Fire Station and in the yard beside it. It is now in the courtyard outside the La Porte County Historical Society's Museum.

A service honor roll containing the names of WWII veterans inscribed on metal plates was erected on the courthouse yard in 1944. The roll was contained in a glass-enclosed board 26 feet long and 7 feet high, and was substantially constructed to last for generations. There were 7 panels with memorial panels in the center carrying names of servicemen who lost their lives. Initially, there were more than 1,800 names and more would be added by the Hubner- Swanson VFW Post. In 1959, the VFW requested that a marble slab be erected to replace the honor roll. The exact date of the removal of the honor roll and its disposition are not known and no other memorial was erected at this location.

The La Porte City Band was organized on August 14, 1879. In 1908, the bandstand was erected on the southwest corner of the courthouse lawn where concerts were played weekly by the band. George Wood Allen was the architect for the structure. By the 1930s, concerts were being held regularly at Fox Park and by 1942, all of the summer concerts were in the park. The structure had deteriorated badly and was in need of a new roof. The expense was not deemed wise, and it was ordered that the old bandstand be demolished.

# *Seven*

# COMMERCE

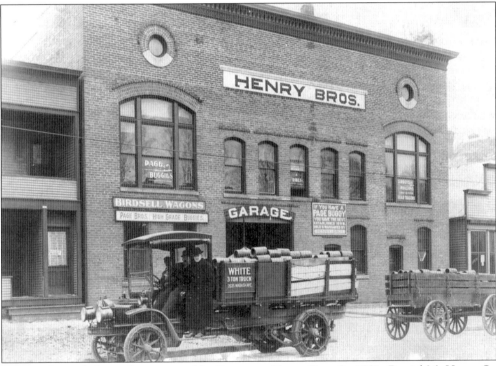

Among the early livery businesses of La Porte was Henry Bros. In 1881, Daniel M. Henry Sr. moved from Scipio Township in La Porte County to La Porte where he and his sons established such a business. In addition to the livery, they boarded horses and had feed stables. They sold carriages, Page buggies, both light and heavy Birdsell farm wagons, phaetons, buggy whips, and robes. Henry also entered the undertaking business, which, in the early days, went hand-in-hand with the livery business. Buggies and wagons were rented for funerals and horses were needed to pull them. In 1912, he retired from the business. By then, the barn had become an up-to-date automobile garage, repair shop, and salesroom for automobiles, wagons, and buggies. The location of this activity was Lincoln Way and Chicago Sts.

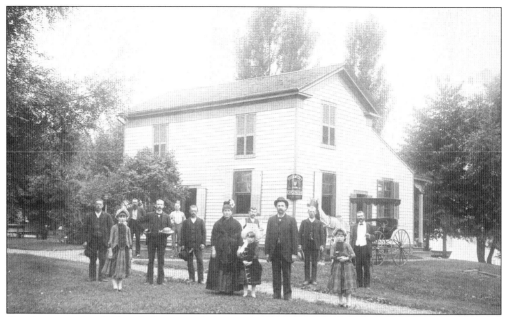

On the east side of Clear Lake on Park St. was Fred Wilhelm's German Beer Garden. The lady and gentlemen in the front row center are identified as Mrs. Fred Wilhelm and Fred Wilhelm. John Wilhelm was a bottler and agent for Cream City Brewing Co. of Milwaukee and a sign advertising this drink hangs on the corner of the building.

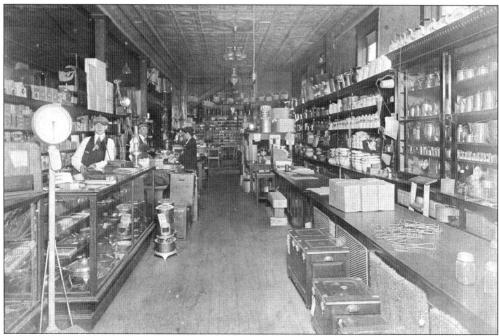

Hardware stores handled everything from nails to tea kettles. James Lower Sons Store at 522-524 Lincoln Way in 1916, is evidence of the variety of items available. There was also a scale for the convenience of customers to weigh themselves. Here we see George A.J. Miller (apparently an employee), Stephen W. Lower, and Mrs. Jones (a customer).

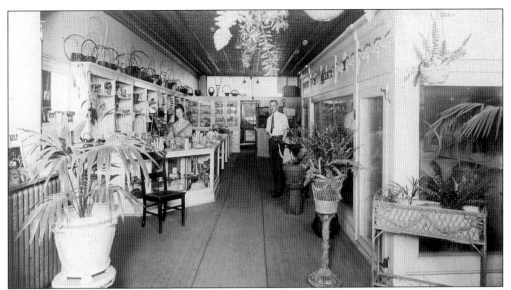

In the early 1920s, the Kaber Company was a thriving floral business. The greenhouses were housed under 25,000 feet of glass and a flower shop was opened at 812 Jefferson Ave. In 1931, the business was sold but continued to carry the Kaber name. To this date, it is still Kaber Floral Co., although the business was moved to 714 Lincoln Way and more recently to the northeast corner of State and Clay Sts.

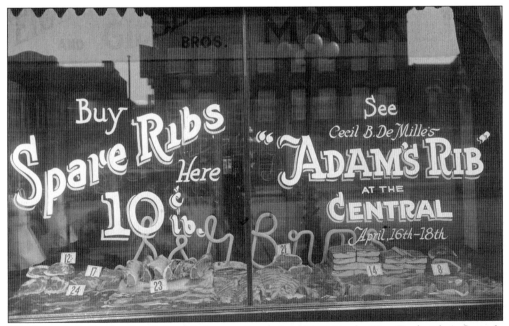

The Steigely & Giesler Bros. Meat Market was located at 1008 Lincoln Way. Frederick A. Steigely worked as a butcher for most of his lifetime and owned and operated a meat market that had been his father's and grandfather's business before him. The Giesler brothers, Emil J. and Max E., joined him in the business. In 1923, one of the local movie theaters (Central Theatre) was showing a movie called "Adam's Rib," so they took advantage of the name as an advertising gimmick. Later Steigely sold the business to the Gieslers and purchased another in Valparaiso.

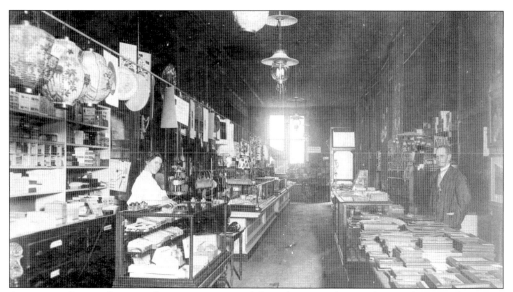

A variety of sizes of picture frames are a part of the selection of items for purchase in this store. As with many of the Lincoln Way stores, diverse inventory was required to fill the orders of the varied needs of the customers.

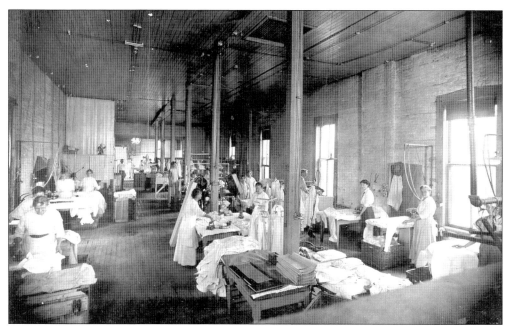

The American Laundry had a modest business at the northeast corner of Main (Lincoln Way) and Perry Sts. It was up for sale and E.N. Schafer and John L. VerWeire became co-owners on April 7, 1893. The business moved to the corner of Michigan Ave. and State St. about a year and a half later in a building formerly occupied by a German newspaper. By 1937, the company employed 40 people and had a fleet of 5 trucks. At the time of this picture (c. 1918), it was still the American Laundry. The name did not change to Schafer's Laundry until much later. This is the press room where, regardless of how cold or hot the temperature, it was a very warm experience. The building was razed in 2000.

Everything and anything needed in the line of harnesses, saddles, and trunks could be purchased from Wm. F. Mann. In 1874, his place of business was located on the west side of Indiana Ave. between North (State St.) and South (Lincoln Way) Main Sts.

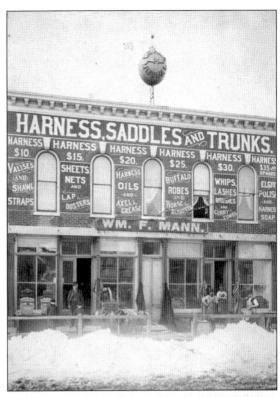

In 1913, Levine's Boston Store opened at their third location in La Porte at 500 Lincoln Way on the southwest corner of Jackson St. Ladies' hats were very much in fashion at this time and the hat or millinery department offered a fine selection. Feathers were also a very "in" thing and most of the hats came adorned with plumes of various sizes and colors.

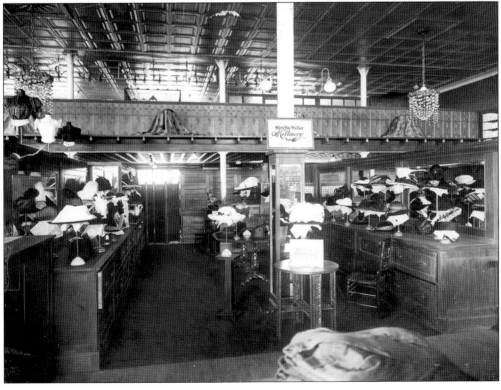

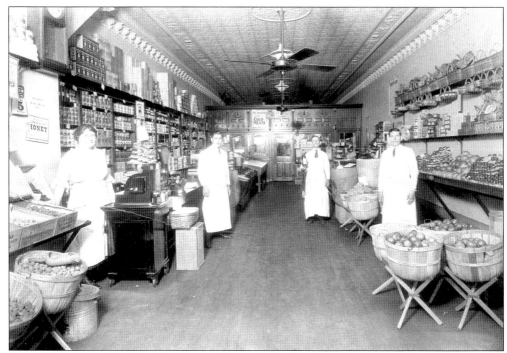

In season fresh fruit of all kinds, nuts, and even cold meats and a supply of canned goods could be found at the California Fruit Store located at 606 Lincoln Way on the north side of the street. Left to right: Maude Reece Owens, Jim Petros, Bill Loftus, and Mike Vulekos.

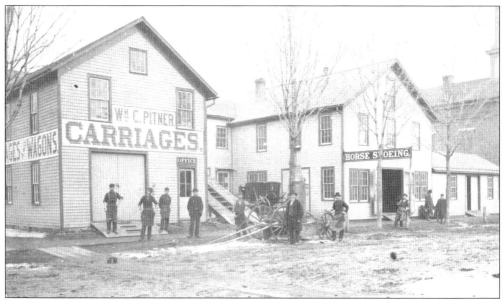

On the southeast corner of Monroe St. and Jefferson Ave., in 1853, William C. Pitner established Pitner's Carriage Works. Thomas Croft was later taken in as a partner, but in 1867, it again became the property of William C., Henry, and Henry B. Pitner. The firm employed 12 hands at that time, manufacturing and repairing carriages and wagons. In conjunction with this, he operated a horseshoeing business. The company was discontinued about 1898.

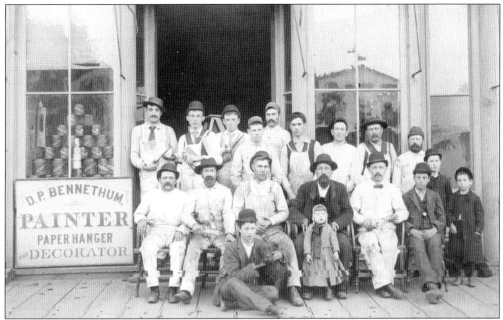

For paint, paper hanging, and decorating, David Pierce Bennethum was the one to contact. For 36 years, he was in business and the address above the door is 56 and also 517. This was during the time when street numbers were changed from two digits to three. This particular address was originally 56 East Main. The company had also been known as Carter & Bennethum and was located in the basement of 62 Michigan Ave. When it was known as Bennethum & Hildebrand, it was located at 619 Main and later, at the same address, again became D.P. Bennethum.

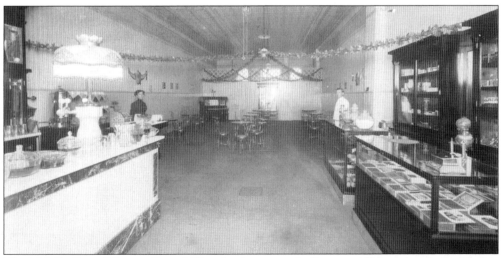

The Mobille Bros. (Thomas G. and Theodore) came to La Porte in 1910, and with the Moshos Bros. (John and Sam) opened the Candy Kitchen, a confectionery at 705 Lincoln Way. In 1912, the Mobille Bros. disposed of their interest to the Moshos Bros. Homemade candies of all kinds, flavors, and descriptions were made in the tiny shop by the Greek owners and helpers. Monstrous bars of chocolate were consumed and the recipes produced hand-dipped chocolates and other goodies. "Our own ice cream made from pure cream only" was advertised with sodas and ices for 10 cents and sandwiches from 10 cents all the way up to 40 cents. The business closed in the early 1970s.

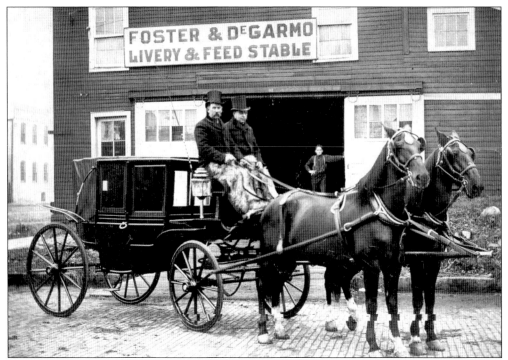

The livery and feed stable of Foster & DeGarmo was, in 1897, on the northeast corner of State St. and Indiana Ave., the location of the former La Porte County Jail. James M. Foster and David J. DeGarmo operated this business and are seen here on the carriage seat.

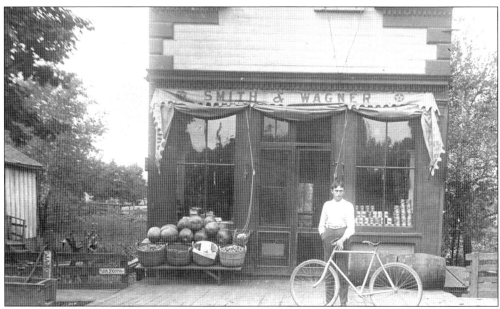

There were many grocery stores in business throughout La Porte serving each ward or neighboring community. Residents did not have transportation to take them very far for their shopping. Smith & Wagner Grocery, at 106 J St., was just one of these very necessary stores. William Smith and Charles Wagner were the owners and offered "staples and fancy goods" in 1902.

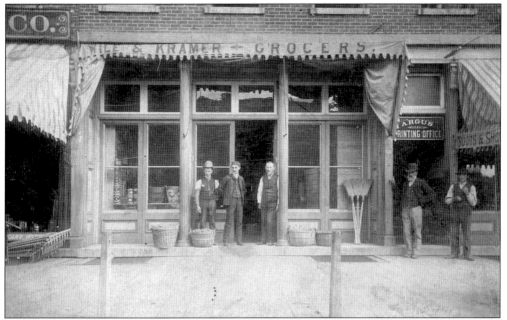

When Isaac Kramer came to La Porte, he was employed by Simon Wile and Mr. Freeland. When Freeland died, he became a partner to Wile and the firm was called Wile & Kramer. The business was a general store, supplying merchandise to retail trade as well as to smaller stores in and around La Porte and La Porte County. In 1884, it changed to wholesale only and became Kramer & Sons. The original retail store seen here was conducted at 718-720 Main (Lincoln Way). The store was built at the close of the Civil War.

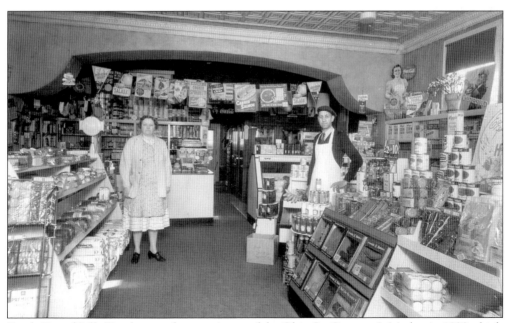

Frank G. and Lilly Doede were the proprietors of the Ohio St. Grocery & Market in 1930 which was located at 609 Ohio St. Their advertisements read "stock is fresh and clean" and "telephone us your orders and we will deliver them promptly."

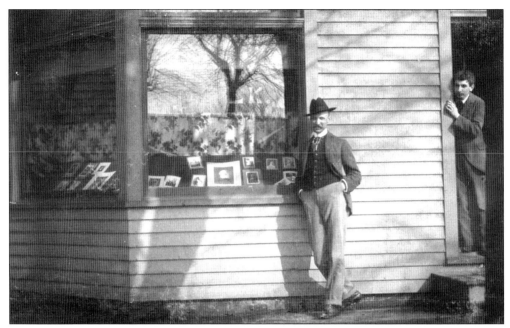

In 1896, Walter E. Dolk established the Dolk (Photograph) Gallery at 803 Michigan Ave. He was a native La Portean, born here in 1868. He was engaged in the art of photography since 1886, and before starting his business here, worked in that field in South Bend. To entice business, he made it known there were "no stairs to climb" at his location and that "no matter what you want in the way of pictures, life size or minuettes," he could provide them.

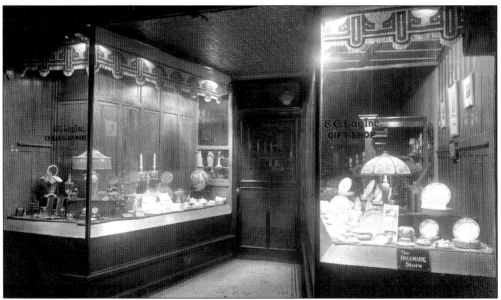

Haviland china, glassware, and gifts could be purchased at E.C. Lay, Inc. Gift Shop located at 812-814 Lincoln Way. This is a view as the storefront looked in approximately 1924. In 1933, Cedric E. Kemp, who had founded the La Porte Supply Company in 1926, started the C.E. Kemp Company at this location. It is recorded that the pillars in the rear of the store that were in place during the times of E.C. Lay can still be seen today.

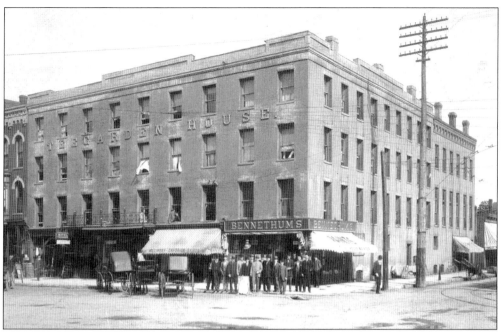

Of the several hotels in the area, the Teegarden House was probably "the place" to stay in the early years of La Porte. It was built by Dr. Abraham Teegarden in 1851-52 on the southeast corner of South Main (Lincoln Way) and Monroe St. It contained about 100 rooms, "most of which are furnished in an elegant manner and all kept well ventilated and scrupulously clean. The tables are supplied with a great variety of the best eatables in season which are well cooked and served in a clean and tasty manner by polite waiters."

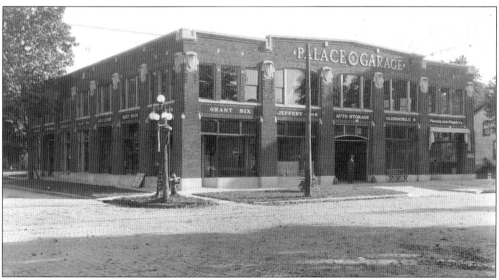

With the automobile came the need for repair shops and the Palace Garage was built in 1916 by Carl Petering on the southwest corner of Lincoln Way and Chicago Sts., the architect being Arthur C. Steigely. The Oldsmobile 8, Grant 6, and Jeffrey 4 and 6 were sold and serviced on the first floor. Upstairs was rented by the Ernest A. Couturier Co., maker of band instruments. This company was sold to Lyon & Healy in 1924.

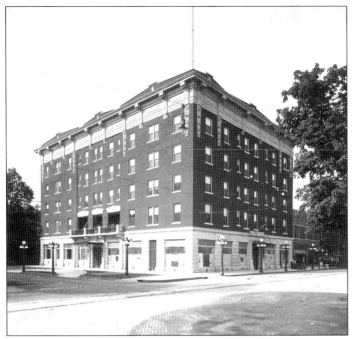

Built in 1912 by Dr. Edward A. Rumely, the Rumely Hotel located on the southwest corner of Michigan and Jefferson Aves., was a 100-room hotel which opened its doors on July 1, 1913. It is a Renaissance Revival structure and Charles Weatherhogg was the architect. In the 1960s, it was closed as a hotel. It has now been remodeled and is known as Rumely Historic Apartments.

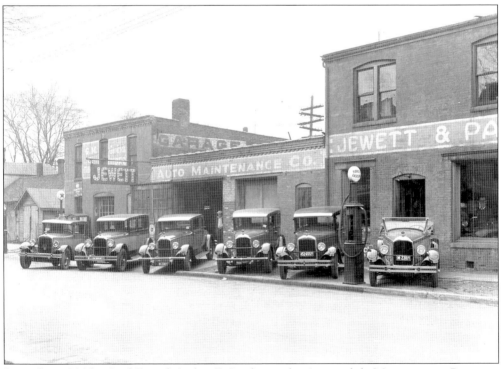

Started in 1906 by Axel E. and Archie E. Lindgren, the Automobile Maintenance Company was located at 808 Monroe St., on the west side of the street between Jefferson and Maple Aves. They were dealers in Jewett, Page, and Dodge automobiles. The business was closed in 1945, and at that time John F. Hummel was president and Allan E. Worden, secretary. This property was later purchased by Kabelin's and used as a service center.

# *Eight*

# INDUSTRY

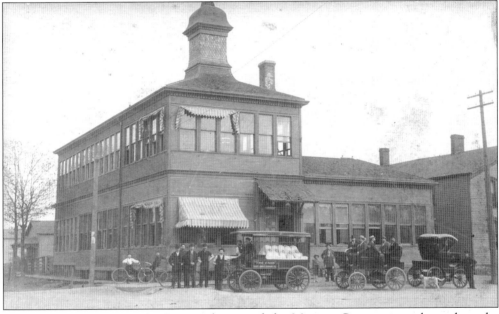

Automobiles were once a La Porte industry and the Munson Company was located on the southeast corner of Michigan Ave. and Washington St. The "horseless carriage" is reported to have been produced here between 1896 and 1902, but it may not have been in continuous operation during these years. The vehicle seen in the center of the three shown here in front of the business is the same one driven by Edwin Beeman in 1899 "to New York City to demonstrate it to eastern capitalists who might be interested in buying stock." It was reported to have been the first car to have been driven along Riverside Drive in New York. The cars were entirely successful but ownership of the company changed. The car was spacious, and as many as 11 people had been known to ride in it at one time. Only four of the Munson automobiles were manufactured in La Porte. The 1900 Munson (on the right) was a 7-horsepower, gas-electric horseless carriage with 4 speeds: 2, 4, 8, and 16 m.p.h. The truck at left is lettered "The Fair" and was delivered to that store in Chicago shortly after this photograph was taken in 1901.

The environs of La Porte and a large portion of La Porte County are primarily known for agriculture. This typical farm home and outbuildings are representative of this industry. Many farms are made up of a substantial amount of land producing large quantities of grain, cattle, hogs, etc. Sometimes the buildings were located a considerable distance from the main roads, down what is called a "lane." These lanes were mostly dirt and sometimes when the spring rains or the winter snows came, they were impassable.

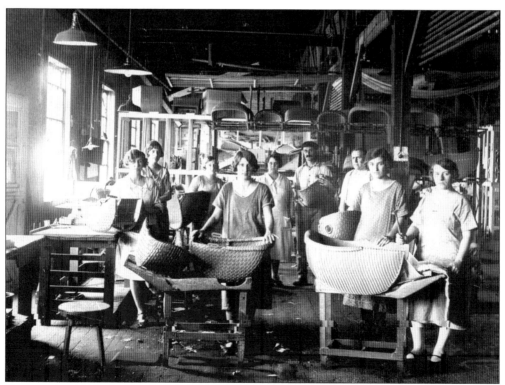

Organized in 1915, the Kumfy Kab Company began operation in its own plant at 305 Detroit St. The company manufactured baby carriages, sulkies, and cabs, and, for a short time, reed sunroom furniture and lamps. This is the work floor where the women were employed making carriages.

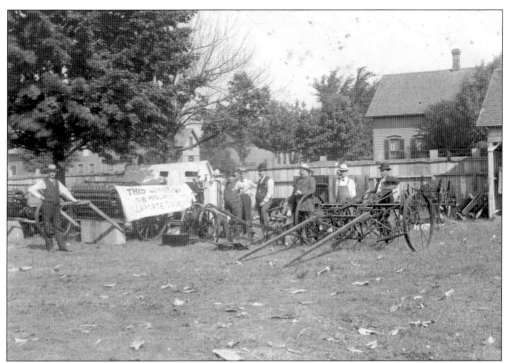

Each year, during the La Porte County Fair, businesses and industries had an opportunity to display their wares. Guy B. Holmes was in the farm implement business for more than 45 years in the same location in Kingsbury south of La Porte from 1902. This display from around 1910 was at the fairgrounds when it was located at 10th and I Sts., the site of the current La Porte High School.

The oldest retail ice trade was established here in 1851. Ice houses dotted the shores of the lakes including Pine, Clear, Stone, and Fish Trap. Here the ice squares are being moved with pointed iron bars from the lake to steam-driven conveyors which would lift them to the storage house. These houses varied in size and were insulated with sawdust, hay, and marsh grass. Because of the houses' makeup, many fires occurred. Ice was shipped to Chicago, Lafayette, Indianapolis, Cincinnati, Louisville, and intermediate points.

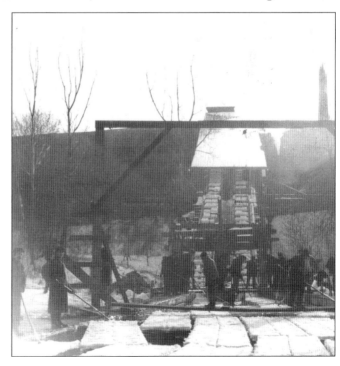

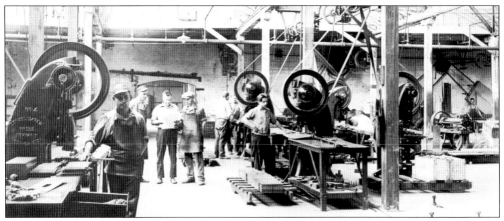

The name of the J.C. McFarland Company at 229 Factory St. was changed in 1926 to Metal Door & Trim because McFarland was no longer actively with the firm and the products of the company were well established in the building field. This interior view is of the first floor which was used entirely for manufacturing purposes while the second story contained the company's office. The company was nationally known for furnishing materials from Maine to California and in such buildings as the Chrysler Building and Empire State Building in New York, the Palmer House in Chicago, and the Los Angeles County Hospital in Los Angeles.

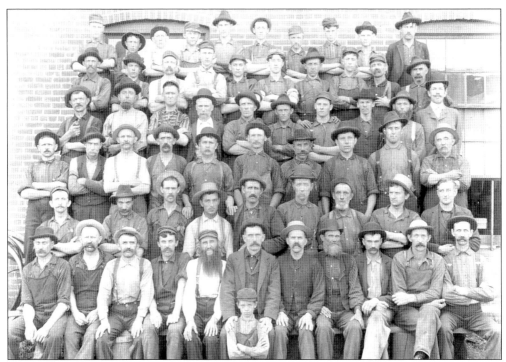

Located on the south side of Lily Lake, the Niles & Scott Co. Wheel Factory, incorporated in 1881, manufactured wheels of wood and metal of almost every description. This company was initially established in 1870 as the La Porte Wheel Company. In 1899, these men were among the employees of the company which, when the various departments were running to full capacity, employed 150 men. This was the only firm in the United States that had the right to weld spokes into the hubs by use of electricity, which gave them an advanced position in the market.

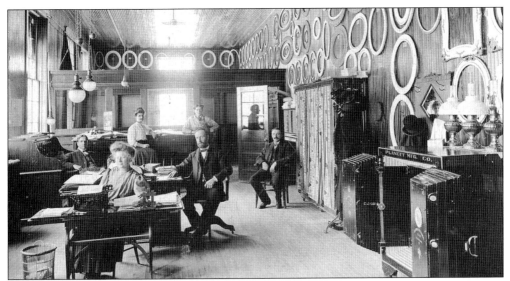

In 1902, negotiations were made with Charles F. Planett of Chicago, who was then engaged in manufacturing picture frames and moldings, to move his plant to La Porte. In 1903, construction of a building at 229 Factory St. (which later housed Metal Door & Trim) was begun for the Planett Factory. The company continued to do a big business until 1907, when it ran into financial problems and was forced into bankruptcy.

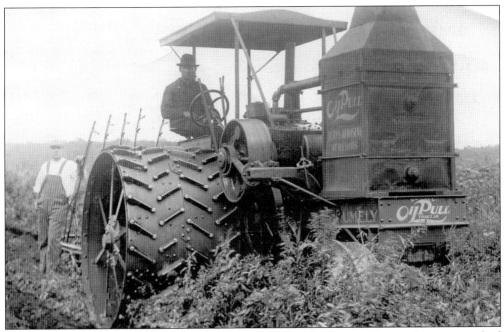

Before 1908, the Rumely Company had very successfully manufactured engines but no name had been given to them. In the shop they were known as "Kerosene Annie" but the registered company name was "OilPull." The OilPull played a very important part in the success of the Rumely Company, expanding its sales considerably. However, a combination of poor harvest years and the credit crunch brought on by the beginning of WWI, forced the company into receivership, and in 1913, it merged with the Advance Corporation of Battle Creek, Michigan.

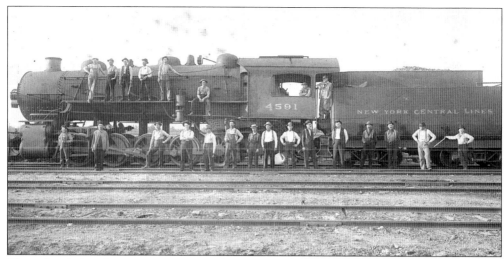

The railroad played an important part in the progress of La Porte. It put local industry in contact with the markets all over the country and even the world. The first engines, wood-burners, meant there was a need for men to cut wood for fuel. Construction workers were in demand for the building of the railroads. Repair shops came into existence and early on, there was a company which constructed some of the engines. Restaurants and hotels also were in demand for passengers as well as crews who chose to make an overnight stop. This 1916 New York Central Line train, in front of the depot, ran on lines of the earlier Lake Shore & Michigan Southern Railroad.

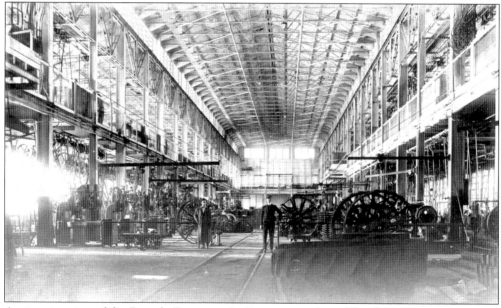

An interior view of the Rumely Factory in La Porte is seen here. The factory covered 85 acres of ground and employed over 2,000 men. It was in 1853 when two brothers, Meinrad and John Rumely, started a small establishment in La Porte which proceeded to become the largest employer in the town. In June of 1931, the Allis-Chalmers Company of Milwaukee, Wisconsin completed a deal with the Advance-Rumely Corporation, whereby the property was transferred to that company.

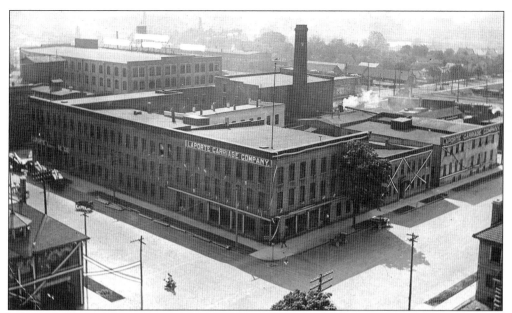

Located on the northwest corner of State and Indiana Avenue, the La Porte Carriage Company, established and incorporated in 1890, had a total floor space of 5 acres. The plant had a capacity for manufacturing 10,000 vehicles annually. All of the carriage bodies were built from clear yellow poplar. In 1905, the company employed 250 men in the offices and works and two watchmen to patrol the building at night.

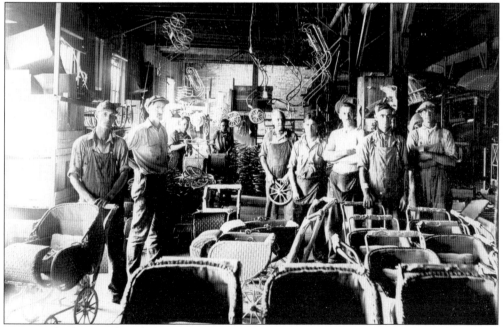

At its peak, the Kumfy Kab Company, at 305 Detroit St., employed 150 people. In this part of the shop, the men affix wheels and handles to the carriages manufactured by the company. The company's operations were discontinued in 1931, after reportedly having paid out over a million and a half dollars in wages to workmen.

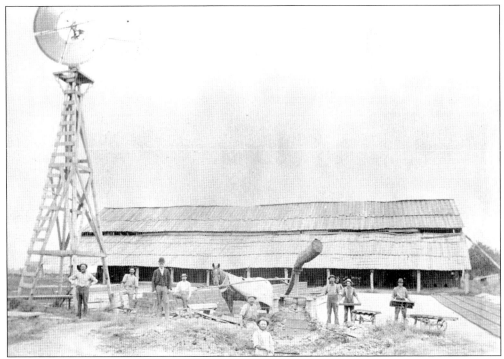

The Hoover brick manufacturing operation was located in Center Township north of La Porte. In 1898, Hoover joined Flory, Wright & Son, brick manufacturers, combining their interests and establishing the La Porte Brick Exchange. At that time, they also handled pressed paving, fancy and general building brick. The capacity of the two plants combined was 50,000 bricks daily.

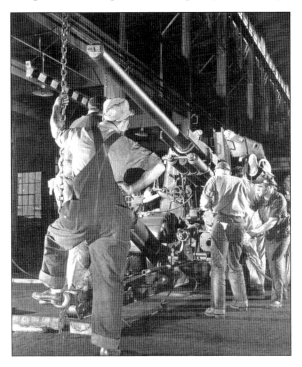

Although a manufacturer of farm machinery, during WWII, Allis-Chalmers Manufacturing Company, like many other companies, was awarded a number of government contracts. Here we see employees of the company working on the line where 90 mm guns were manufactured.

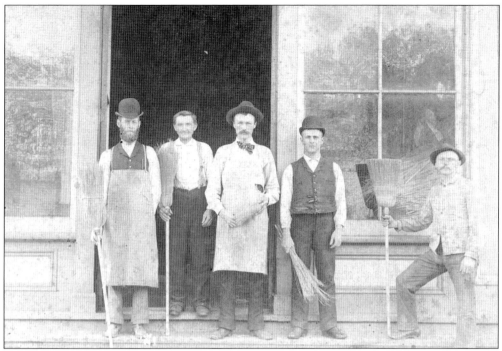

Between 1880 and 1890, there were five broom makers in La Porte and at one time, the town was noted throughout the State of Indiana for the number and quality of brooms manufactured here. The Wise and Haferkamp Broom Factory was located at the corner of Teegarden and State Sts. and in 1888, was moved to 1111 Main (Lincoln Way) where they remained in business until 1932. At that time, the broom manufacturing business had diminished leaving only one small shop operating in La Porte.

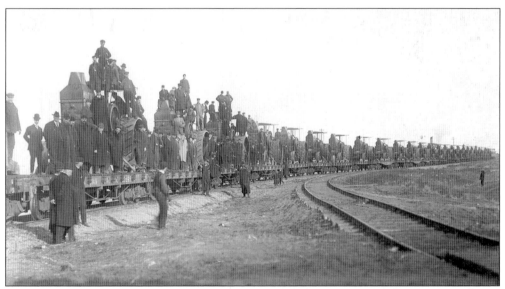

The OilPull engine, manufactured by the Rumely Company of La Porte, was very popular in Western Canada. In this photograph of 1910, the first trainload of the OilPulls is arriving at Regina, Saskatchewan. It was met a mile and a half from the station by a crowd of 300 people.

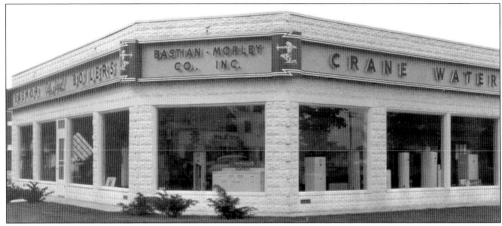

During WWI, Bastian-Morley Co., Inc. moved to La Porte. They entered into an arrangement with Crane Co. to manufacture water heaters under the Crane name for national distribution. The company was located at 200 Truesdell Ave. on the southeast corner of Pine Lake Ave. During WWII, in addition to supplying water heater products to the military, they produced such items as airplane fire walls, bomb fuses, and the T-6 B pontoons described as "The Slickest Trick of the War." In 1967, the company went into receivership.

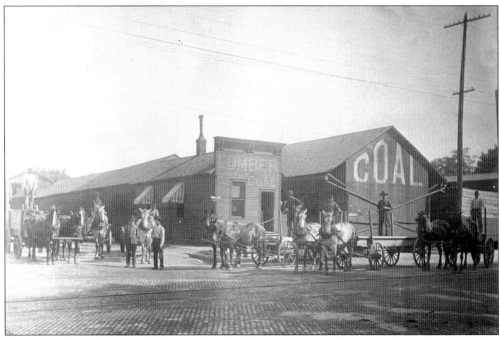

The main office of Moore & Richter Lumber Company, as seen here, was located at 423 Main St. (Lincoln Way), on the northeast corner of Main and Jackson Sts. Later it was located on the east side of Jackson St. (just around the corner). It is evident by the number of wagons with lumber already loaded that much building was going on in the area at this time. In addition to lumber, the company offered coal to the consumer, this being the heating choice for many.

During WWII, the U.S. Government purchased 13,454 acres south of La Porte for the purposes of erecting a plant for the production of ammunition for the military. The first shell rolled off the line on August 21, 1941. This photograph shows the main office buildings and parking lot inside the entrance to the facility. The plant was put in "moth balls" after the war but was reopened in 1951 with American Safety Razor Company operating it until final closure in 1960.

After outgrowing its facilities in Chicago in 1915, the U.S. Slicing Machine Company opened in La Porte and located to 333 Larson St. in a building erected the previous year by local contractor, Larson & Danielson Construction Company. Local high school ball clubs chose the name "La Porte Slicers" for their teams as a result of a citywide contest held in 1917. In 1970, the name of the firm was changed to Berkel, Inc. Besides slicing machines, the firm produced such items as choppers, food cutters and processors, and digital scales. In 2001, it was announced the plant would be closing.

Monarch "Teenie Weenie" Toffee was manufactured in La Porte at the Reid, Murdoch & Company facility. The company came to La Porte in the summer of 1928, occupying the building known as the McLelland, Buck, and Wise building located on Lake St. west of the waterworks. It had a work force of about 200 when operating at full capacity and made other candies such as Surprise Patties, Old Fashioned Mints, Mallowettes, and Fruit Jellies. The factory was an important part of the community providing employment to many throughout the depression years. It discontinued operation in 1942 when it became difficult to purchase sugar and butter.

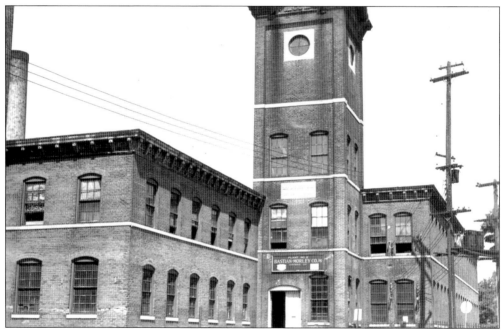

In 1937, the Chicago Garment Company moved from the Great Western plant on Washington St., where they had been for seven years, to this building on Park St. known at that time as the Mercoid building, named after a company which never saw its way clear to move its plant here. The garment company found a need to expand and to hire more than the current 300 employees and this building offered the opportunity. It also meant that all of the machines could be placed along the windows so operators would have daylight by which to work. The company occupied the entire second floor and the lower floor was used by the Bastian-Morley Company. This building had housed various enterprises and probably most people would remember it as Kingsley Furniture Company.

# *Nine*

# PEOPLE

La Porte became a county in 1832, and in 1837, Dr. Abraham Teegarden reached La Porte. He was born in Columbiana County, Ohio and spent his early years working on his father's farm. Later he studied medicine in the office of his brother, Dr. Eli Teegarden in Mansfield, Ohio and attended medical lectures at Washington College, Ohio. Just before coming to La Porte, he graduated from the Cincinnati Medical College. He was a strong abolitionist, serving for years as a "conductor" on the Underground Railroad. His name was prominent later, having erected the Hotel Teegarden in La Porte and also naming the village of Teegarden, Indiana. The hotel was built in 1851-52 on the southeast corner of Lincoln Way and Monroe and for over 60 years, James Lower rented the east room where he conducted his hardware business. The hotel was a popular place for visitors to the area. The doctor was elected a Trustee of the New Church Society in 1859, when the legal incorporation of that society was recorded. He partially retired from the medical profession in 1870, and he died in October of 1883 from the effects of a fall while repairing the doorway of his hotel.

In his home workshop, Frederic A. Craven, an employee of the Rumely Company, is building ship models. He was widely revered for his skill and expertise in this field. It is reported the first ship he chose was the clipper ship Santa Maria, flagship of Columbus. In 1930, he decided to devote all of his time to this "hobby" and he received high recognition for his artistry. He was commissioned by the Julius Rosenwald Foundation of Chicago to build a group of famous ships and a number of these models were sent to the Museum of Science and Industry in Chicago for display. "The Flying Cloud" model is on display in the La Porte County Historical Society's Museum.

Many prominent and well-known people have paid a visit at one time or another to La Porte. Dwight David Eisenhower, during his first presidential campaign, stopped at the New York Central Depot on September 15, 1952. He met Dwight Graham, a local Cub Scout, who had been named for the general. Graham went on to graduate from La Porte High School and Ball State University and become a teacher at Prairie State Junior College, Chicago Heights.

Born in La Porte on May 12, 1883, African-American Hazel L. Harrison became a world-renown pianist. Her first piano instructor was Richard W. Pellow who was organist at the Presbyterian Church and director of their choir. Later she studied with Victor Heinze and traveled to Germany for two different periods to study with Serruccio Vusoni. She was with the piano department of Howard University, Washington D.C. for a number of years and taught briefly at State Normal in Montgomery, Alabama. Early on, her talent was recognized, and she later became La Porte's most brilliant and accomplished pianist and a musician of international fame.

Coming to La Porte County in 1856, Jasper Packard engaged in school teaching, became Principal of the high school, and subsequently was elected Superintendent of the County Schools. He studied law and in 1858 was elected justice of the peace. He was admitted to the bar in 1861 but never practiced. During this period, he also edited the *La Porte Union* newspaper. He enlisted in 1861 in the Indiana Volunteers, attaining the rank of Colonel. He was brevetted brigadier general in April 1865. After the war he was involved in the political area, serving in the State Legislature. In 1899, he was offered and accepted the position of Commandant at the State Soldiers' Home at Lafayette which he accepted. He held that position at the time of his death that same year.

In this family portrait Harry N. Pendleton, his son, Reginald, and his wife, Katherine Good Pendleton are seen. Harry was one of the oldest automobile dealers in the city based on the number of years in business. When airplanes came into their own, Harry became affiliated with the Aero Exhibition Company in Illinois, learned to fly, gave instructions, and took up passengers. He gave that up when the company failed financially. His son, Reginald (Reggie), later joined him as a partner in the operation of the Oldsmobile sales and service agency on the southeast corner of State and Monroe Sts.

A native of La Porte County, Dr. Harvey H. Martin came from rugged pioneer stock that contributed immeasurably to the settlement and development of the county. He received his medical training at Ann Arbor Medical School and Chicago Homeopathic College and graduated with honors in 1895. He was involved in many outstanding activities of a civic nature. He will probably long be remembered for the exemplary work done as General Chairman of La Porte's Centennial observation during the summer of 1932.

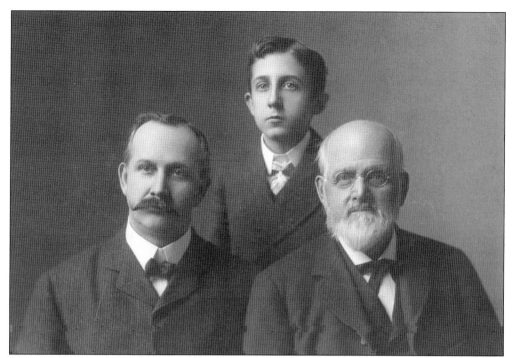

Three generations of the McLane Family, George, Howard, and Bird are seen here. Bird came to this county in 1832. His son, George, was born in Noble Township in 1858 on the McLane farm. In 1891, he and his wife moved to La Porte and purchased an interest in Weaver and Frederickson Dry Goods firm. Their son, Howard, received his early education in La Porte and received his doctor of jurisprudence at Chicago in 1917. He practiced law here until entering the service. From 1928 until his retirement in 1958, he operated the McLane Apparel Shop at 520 Lincoln Way.

Agriculturist and former Mayor of La Porte, Emmet Hoyt Scott, was a great contributor to La Porte and the community. He donated generously to the Ruth C. Sabin Home and the Holy Family Hospital. With the aid of Capt. A.P. Andrew, Mr. Scott procured the first county agent of La Porte County as well as the first one in the state. After spending some time pursuing his interest in farming, he returned to La Porte and acquired an interest in the wheel factory, the name of which was changed to Niles and Scott in 1881. Through the greater part of his active business career, he was connected with the lumber trade and kindred industries.

Arriving in La Porte in 1840, John H. Bradley was engaged for a short time as a civil engineer, assisting, among other things, in the surveying and building of the Michigan Southern and Northern Indiana Railroad. He began his law practice in 1841 and continued in that field until advancing age compelled him to relinquish it. In 1850, he was elected to the Legislature serving one term. President Franklin Pierce appointed him one of the judges of the Supreme Court of Nebraska in 1854, an office he filled for three years. He was elected to the State Senate in 1868 and later served as both city and county attorney.

When we see the statue of the "Potawatomie Indian," located in Independence Plaza between the La Porte County Courthouse and Complex, Howard DeMyer, renowned artist and La Porte native comes to mind. He was educated in the La Porte school system and took his law degree at Indiana University. He returned to his hometown where he practiced law and served as city councilman and prosecuting attorney. The statue, which has become an important part of La Porte's landscape, was presented to the county on July 1, 1978, at the completion of the bicentennial celebration.

Many of the legal problems of La Porte were probably handled by Norman H., Milton J., and their father, Herman W. Sallwasser. The elder Sallwasser, a native of Germany, came to La Porte at the age of five and became one of La Porte's foremost citizens. He served as Mayor of La Porte for eight years and was also city judge at that time. The younger Sallwassers were natives of La Porte and both practiced law here. They were very active in legal and civic organizations and their church. Milton J. served as Clerk of the Circuit Court and Norman J. was Judge of Superior Court 1 in Michigan City.

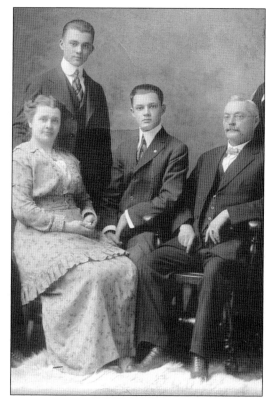

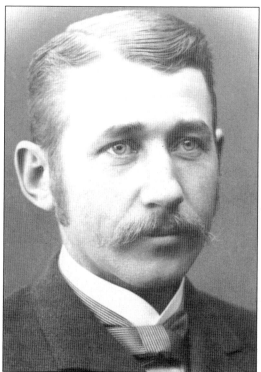

After 1879, when he came to La Porte, the name Albert J. Stahl was synonymous with banking, real estate, and insurance business. He organized the La Porte Electric Company and later, along with four others, purchased the telephone property that was the first, or experimental, and demonstrating plant of the Strowger Automatic System. His business office was at 602 Lincoln Way (on the southwest corner of Lincoln Way and Clay Sts.). He devoted his finances and energies to acquiring, improving, and renting properties, including many apartment buildings.

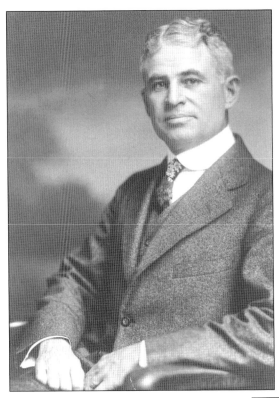

Because Edward N. Schafer was a skilled musician (a clarinetist), La Porte had one of the most thriving businesses, the American Laundry, and also one of the most prominent and civic-spirited business men. He and friend and fellow-musician, John L. VerWeire, came to La Porte in 1891 to assist the La Porte City Band with a music festival in Valparaiso. They came back a number of times and finally purchased the American Laundry, then located on the corner of Main and Perry Sts. The business was a success and moved to the location of the current jail project where it went through a number of changes before becoming Schafer's Laundry.

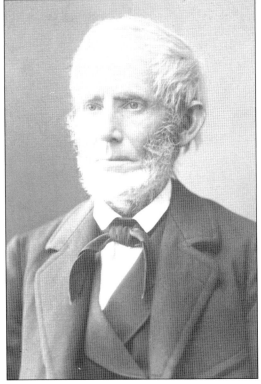

Having taken a contract to build the first 15 miles of the old Michigan Rd. from Madison north in 1829, James Andrew, along with his brother, completed the job and took land scrip for pay. They came here with a view of selling the scrip, but instead were so delighted with the area they decided to locate here and attended the land sales at Logansport for the purpose of purchasing the land, or a part of it, where the City of La Porte now stands. This was in 1831. Thus he was one of the Founding Fathers of La Porte along with John Walker, Walter Wilson, Hiram Todd, and his brother, Capt. Abram P. Andrew Jr.

Born in La Porte on March 20, 1864, Dr. Jacob Wile Jr. attended the local schools and later studied medicine at Michigan University in Ann Arbor. He graduated from that institution in 1885 pronounced a full-fledged M.D. Locally he set up practice with Dr. J.W. Wm. Meyer and met with enough success to establish his own practice. About 1894, he moved to Chicago where he established himself in the "aristocratic part" of that city and was selected as resident physician of the Palmer House. He died at the early age of 32.

In 1908, Wirt Worden achieved wide prominence as the defense lawyer for Ray Lamphere who was tried for murder in connection with the Belle Gunness case. He gained acquittal for Lamphere, who had been a hired man for Gunness, but later was convicted for arson and died a year afterward in the Indiana State Prison at Michigan City. Mr. Worden was born in Rolling Prairie, east of La Porte, and was a graduate of the high school in that town. He obtained his law degree from Valparaiso University and began his practice in La Porte in 1901 with Morgan H. Weir. Later he formed a partnership with Lemuel Darrow.

Having been appointed chief engineer of the Cincinnati, Peru & Chicago Railroad, Newell Gleason made his home in La Porte in 1851. During the Civil War, he received a commission as Lieutenant Colonel of the 87th Indiana Volunteers. Later as Colonel, he commanded the regiment through the campaign ending with the Battle of Chickamauga and participated in the famous march to the sea. He was brevetted a brigadier general of the U.S. Volunteers on June 27, 1864. After the war, he served in the Legislature for one year and then returned to the field of engineering.

A soldier of WWI, Hamon Gray was the son of Dr. J. Lucius and Orianna Hamon Gray and was born in La Porte, June 1, 1896. He entered the First Officers' Training Camp at Ft. Benjamin Harrison on May 15, 1917 and was commissioned a 2nd Lieutenant. He went overseas in September of 1918, was assigned to Company C, 9th Infantry, and was wounded on July 19, 1918 at the Battle of Soissons; he died the following day. The Croix-de-Guerre with Silver Star was awarded to him by the French Government. The American Legion Post #83 in La Porte is named in his honor.

Referred to locally as "The Admiral," Adm. Royal Rodney Ingersoll received his early education at Niles in Michigan and entered the naval service as a midshipman on July 23, 1864. He graduated from the U.S. Naval Academy at Annapolis in 1868. He served in all parts of the world at sea and on some of the historical ships of the Navy including the Constitution (Old Ironsides) and many others. After his retirement in 1909, he and his family came to La Porte to live, residing in their newly-erected home at 1202 Indiana Ave. which he affectionately called "Seven Bells."

For over 37 years, Kate Annette Hosmer who was born on a farm near Westville, west of La Porte, was associated with the school system. She came to La Porte in 1890 to teach at the old Third Ward School where she taught third and fourth grades. Later, she taught at Central Elementary and Lincoln School and at one time served as Principal and Assistant Principal. She taught under nine superintendents of schools.

The 40th Governor of the State of Indiana was Harold Willis Handley. Handley was born in La Porte on November 27, 1909 and graduated from La Porte High School in 1928. He attended Indiana University and graduated with an A.B. degree in 1932. He worked with his father at the Rustic Furniture Company in La Porte and in 1941, entered the State Senate for a single session. He won the office of Lieutenant Governor in 1952 and in 1956, won the office of Governor. After leaving office, he worked in public relations and then moved to Rawlins, Wyoming, where he died in 1972.

A lifetime resident of La Porte, John William Bryant, was a descendant of the pioneer Benedict Family. He was a photographer, operating a studio in La Porte as early as 1868. He entered the manufacture of scenic backgrounds and accessories for photographers use and manufactured blackboards for the public schools. In 1878, he established a papier-mache and background factory on Tyler St. which closed in 1896. He moved the building, occupied by the Indiana Medical College, to Tyler Street where he manufactured a new school blackboard he invented. This factory burned down in about 1910 and was not rebuilt.

# *Ten*
# ENTERTAINMENT/
# RECREATION

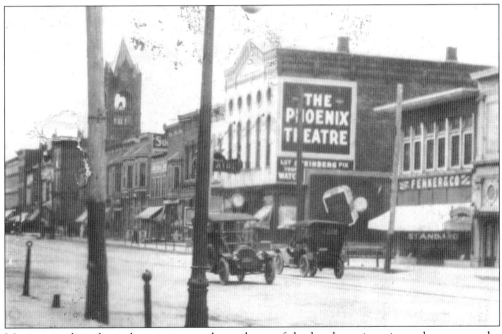

Moviegoing has always been very popular and one of the local moving picture houses was the Phoenix Theatre, at 601-03 Main St., on the northwest corner of Main (Lincoln Way) and Clay Sts. Because of its location, it allowed for advertising on the side which, in this case, prominently displays the theatre's name and below "Let Steinberg Fix Your Watch." Originally, the building was erected in 1858, and was remodeled from about 1864-65. From its beginning, it was the scene of all theatrical entertainment. Although "its accommodations were not of such a nature as justified, many first class troupes in visiting it, yet the scene of the theatrical history" of La Porte literally went up in smoke on December 22, 1875. The building, at that time, was owned by Howell Huntsman and John F. Decker and was known as Huntsman Hall. It was rebuilt the following year by Howell Huntsman and Sebastian F. Lay. During this period, it was renamed Lay's Hall but was also known as the Opera House. It burned again in 1909. S. Steinberg, jeweler, was one of the occupants of the building. It was then remodeled into a moving picture house. Three nightly vaudeville shows were added to the entertainment schedule. The stores on the first floor were removed, making a regular theatre while the top part was made into a dance hall. In 1924, it was again remodeled into a store and office building.

In 1897, Weller's Grove fronted on what is now Weller Ave. In 1886, the grove was the home of Mr. William H. Weller, son of the Rev. Henry Weller. Initially a large tent was raised on the lawn which sloped to the shores of Stone Lake. The tent was well floored and Sunday services were held with sermons by well-known New Church ministers. Later many cottages were built and a large pavilion was erected in the center of the grove.

A common site on Pine Lake c. 1904 included a sailing expedition. Pine Lake is one of the many inland lakes in La Porte County. Few summer cottages dot the lake shore where today there are numerous year-round homes. The lake is a summer tourist attraction for fishing, boating, and swimming. It also attracts winter recreation for snowmobilers and ice fishermen.

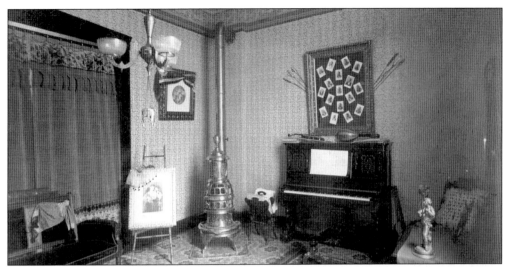

It was the norm for a piano to be the centerpiece of the parlor/living room in a home in La Porte in 1890 and this is a typical home setting. It was a place for the family to gather around and enjoy time together singing the songs of the times. In this case, it is noted that the family was apparently musically inclined as other instruments are also on top of the piano. The room was heated with a wood stove. It was sometimes closed for use and only used when there were guests or for special occasions.

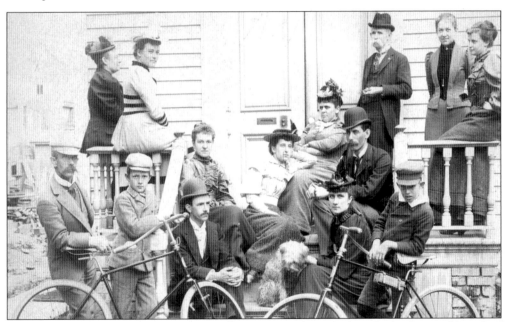

Bicycling was a pastime and a necessary mode of transportation for many. Members and friends of the Michael family visit at their home at 708 Harrison. Because of its popularity, local bicyclers organized the Crown Bicycle Club in 1895 which received its name from the Crown Bicycle which was manufactured in La Porte and was known the world over. The colors adopted by the organization were jet and old gold. Their uniforms were to be gray cassimere knickerbockers and a blouse cut after the military fashion. A light gray golf-type cap with a jet crescent to adorn it bearing the letters L.C.C. in gold completed the outfit.

A party for the members of the La Porte Country Club was held annually between 1925 and 1930. Those attending gather inside the clubhouse for a photo-op. Located on Johnson Rd., the golf links were on the north part of the Pine Lake Assembly grounds surrounding the clubhouse. The club originated in 1905 and shortly after that the first clubhouse was erected. The one shown here was formally opened on July 4, 1923. There seems to be no general theme for this party as we note pirates, clowns, sailors, and others midst the group.

The Teegarden Hotel offered its guests a Game Room. Located on the southeast corner of Lincoln Way and Monroe St., card games and pool seem to be the activities of choice at this particular time. Attractive chairs with cane seats were available, not only for the players, but for spectators. A beverage table where players and spectators could quench their thirst was also available.

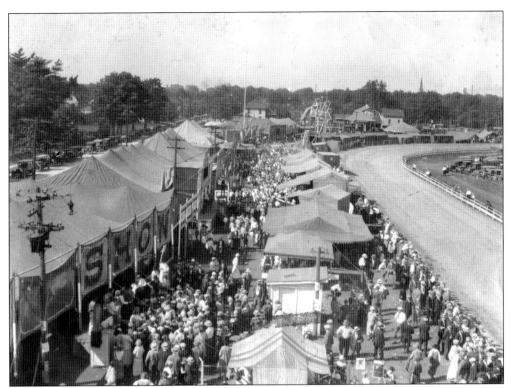

Beginning as early as 1845, the La Porte County Fair was a major attraction. The fairgrounds at 10th and I Sts. were purchased by the commissioners in 1868 and fairs were held on this site until 1961. Many tents with various concessionaires, side shows, and other activities line the midway along the racetrack while attendees were allowed to park in the infield. Farmers displayed their agricultural achievements and the ladies displayed their handiwork and culinary skills. Premiums were awarded in many categories.

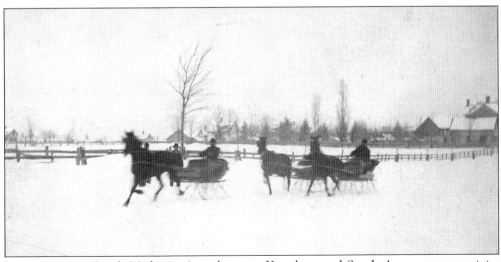

Snow racing on South Michigan Ave., between Kingsbury and South Aves., was an activity open to anyone wishing to participate. In 1885, an adequate snowfall provided ideal conditions for this winter recreation.

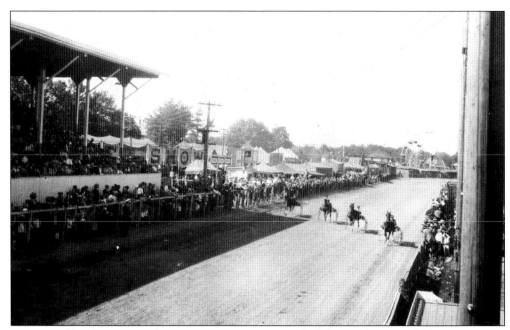

An enjoyable afternoon at the La Porte County Fair included attendance at the harness racing event. The racetrack was constructed in 1873, and in 1901, bookmaking was allowed at the track after a lapse of several years. The grandstand was generally filled to capacity for the races.

In 1881, Albert S. Hall erected what became known as Hall's Opera House located on the east side of Madison St. between Lincoln Way and Jefferson Ave. Mr. Cass Chapman of Chicago was the Architect and the contractors were John P. Vankirk and Henry McGill. Hall, born in Scipio Township, made farming his life work and in 1880 moved to La Porte where he became a "co-operant factor in the material improvement and upbuilding of the town." The opera house was considered one of the finest in the country in its day and some of the best actors and performers appeared there. The building was destroyed by fire on March 31, 1965.

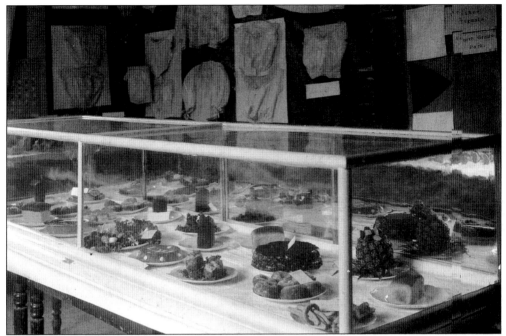

Doughnuts, cakes, and bread, among others, were baking entries in the Home Economics Projects at the 1906 La Porte County Fair. Other types of entries such as sewing projects are also displayed on the wall. Judges awarded the deserving winners many ribbons and awards.

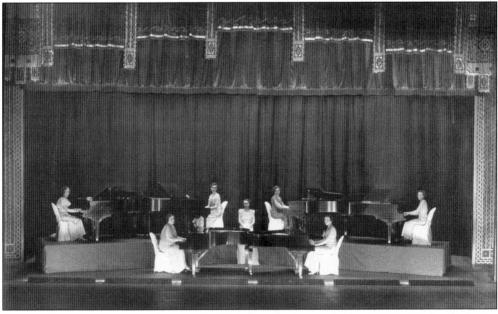

A special piano concert was given at the Civic Auditorium in the late 1930s. Six local pianists participated. Pianos were furnished by Joseph C. Smith who had a music store at 1013 Lincoln Way. Front row, standing, is Mrs. Charles (Ruby) Beal and back row, left to right are Hilda Wegner Pease, Grace Kenny Floering, unknown, and Marjory Schafer. This is believed to have been the only such concert to have taken place here.

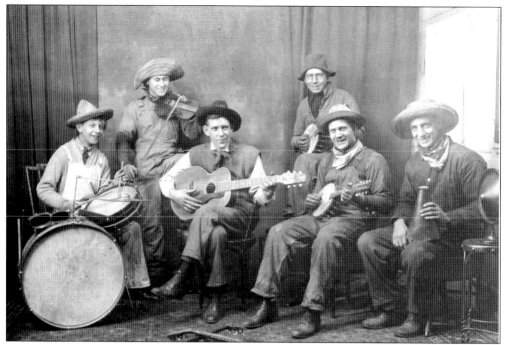

The Sod-Busters was just one of several local groups to perform on WRAF. The radio station was founded in the mid-1920s by Charles Middleton. It was located in the Odd Fellows Building and was known as the "Voice of the Maple City." Some of the local groups went on to perform on the National Barn Dance on WLS in Chicago, among those was the well-known Maple City Four.

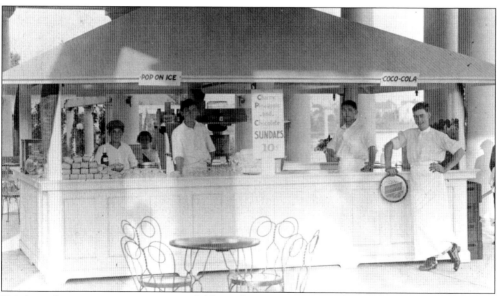

Drinks and ice cream treats were available at the concession stand located within the Fox Park pavilion. Families enjoying a day in the park, listening to a band concert, watching a ball game, or picnicking, seemed to always find the offerings here to be just the little something special to top off the day. The early bandstand was demolished in the 1950s and the band continued to hold concerts in the pavilion. It, too, has now been razed.

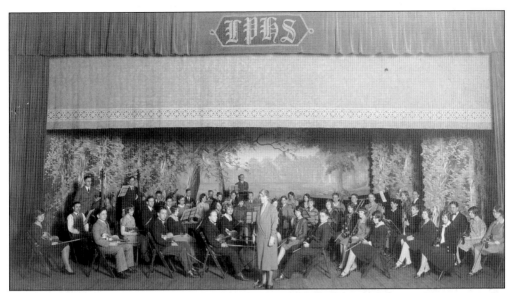

An evening of music was furnished by the La Porte High School orchestra on-stage at the La Porte High School then located at 1000 Harrison St. in the building that is now Boston Middle School. The orchestra was under the direction of Lola R. Vawter, a teacher in the Music Department of the school for many years.

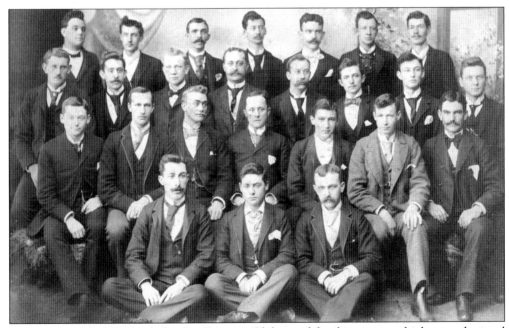

In the spring of 1893, the Columbia Dancing Club posed for this picture which was submitted to the local newspaper's Old Photo Contest. The club was composed of 25 members: (front row) Frank Rachor, Joseph Jaeger, Oma Grischow; (second row) Robert Buck, Albert Lindquist, Ed Zahrt, Henry Mehl, William Kelling, Clarence Wilkinson, John Bower; (third row) George Wiedenbeck, Martin Rachor, Will Keller, Will J. Vogt, Gallus Korros, Frank Maas, Herm Richter, William Buck; (back row) Con Schropp, Chas. Demzien, Augt. Johnson, Len Kugler, John Kreidler, Gust Peterson, Ed Armstrong.

Tennis anyone? Here are Greta Arnold and Kate Clark, when they were about 15 years old, all decked out in their attire and ready to play tennis. Kate was the daughter of the beloved pioneer physician of La Porte, Dr. Abraham Teegarden. She was very active in the community. She was the first guardian of the La Porte Campfire group and worked with the La Porte Charity Circle, conducting an experimental day nursery for children of working mothers.

In 1935, the La Porte Drum & Bugle Corps won the Indiana State Championship. Here they are as they appeared at the inauguration of Harold Willis Handley, native of La Porte, Governor of Indiana: (front row) Harold Horne, Richard Chase, Walter Schimmel, Gale Orr, Walter Martinsen, Wayne Eldridge, William Beeman; (middle row) William Row, Frank Marks, George Pfieffer, Steven Cormick; (back row) Richard Hacksteler, Keith Zook, Charles Link, Maurice Adams, James Garwood, James Healey, Marvin Brown, Lowell Palmer, Wilbur Boardman, Elmer Marhanka, Robert Gregory, Walter Cains, Thomas Sallwasser, Richard Wegner, James Born, Norman Steigley, Merlin Sampson, Gene Hasselfeldt.

A number of local businesses and industries sponsored baseball teams. The Fox Woolen Mills were the sponsors of this team which apparently had been awarded a trophy relative to their playing ability. The year of this award is not known. Front row: Harry Beck, Walter Huge, Warren Bowman, Heine Guelzo, Ed Stoeke; back row: Bob Quinn, George Gehrke, ? Moore, ? Hoelocker, Ray Stoewer, Walt Giese.

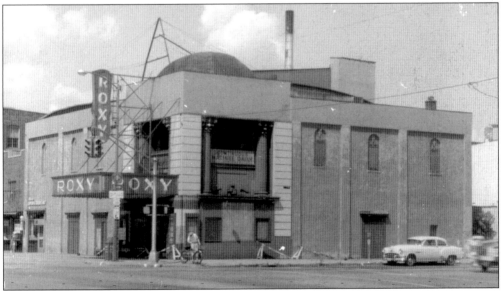

What was to be the New Etropal (La Porte spelled backwards) Theater was built in 1920 on the northwest corner of Indiana Ave. and Lincoln Way. The entire harness company building on the site was to be used with major remodeling. Scott C. Dyer of Chicago was the architect and the contractor was Elmer VanWinkle of La Porte. It was opened in October of 1933 as the Central Theatre, and in August 1934, gala ceremonies marked the formal opening of the new Roxy Theatre shown here in the building formerly housing the Central Theatre.

Band concerts were held at various places in La Porte. In 1911, the La Porte City Band gave a concert at La Porte Washington Park, located off Weller Ave. at Stone Lake. The band gained a reputation of excellence over the years of its existence. It initially consisted of 15 members with Prof. Thomas W. Belcher directing the group from its beginning in 1879 to 1884. He was both a band master and a singing teacher.

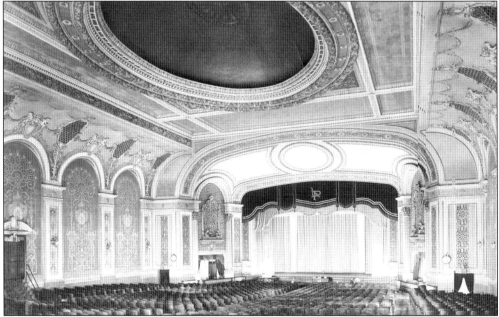

Although La Porte is not one of the larger centers of population, it was fortunate to have had one of the best possible theatres, the La Porte Theatre. The theatre, designed by Newhouse and Bernham, opened in 1923, and was located on the north side of Lincoln Way between Jackson and Detroit Sts. It seated 1,576 people and was separated from the remainder of the building by 21-inch fire walls. It occupied all but 30 feet of the block and represented "the dreams of three men," Jacob Levine, Samuel Steinberg, and Abram Sommerfield. The building was razed in 1977.

# *Eleven*

# MONUMENTS AND MARKERS

This cenotaph was erected by the Grand Army of the Republic Post on the Courthouse square in La Porte for Memorial Day exercises in 1883. It was made of wood and contained the names of the following deceased soldiers of La Porte County (from top to bottom): T.J. Patton, Wm. Patton, D. J. Woodward, Levi Ely, Charles Ely, Henry Ely, Philip McBride, Seth Carver, John Everhart, Daniel Meeker, David Donly, Arthur Sheldon, W. Scott, John Chandler, Almon Lamb, Jacob Hilderbrand, Alonzo Lamb, Philip Miller, John W. Richards, Gilbert Hathaway, John W. Andrew, O. H. Grover, Eugene Pratt, Milton J. Cook, Vincent Rice, Niles Lonn, Alex Robinson, David F. Beach, and E. Farnsworth. The monument was decorated "in the most artistic manner, with the choicest flowers" that had been contributed by the citizens of La Porte. It was expected the exercises of the Grand Army of the Republic would be conducted by the marker but the rain compelled the adjournment indoors to the nearby opera house. The legend at the bottom of the marker reads: *Decorum Est Pro Patria More*, which loosely translated means "It is becoming to die for the fatherland."

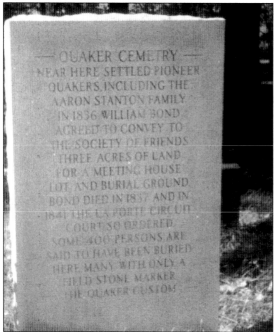

Located in the Quaker (Friends) Cemetery on the north side of La Porte on Park St. is this Quaker Cemetery Monument. The monument was purchased by the Quaker Historical Society for placement in this cemetery where most of La Porte County's pioneer Quakers are buried. As noted on the marker, "some 400 persons are said to have been buried here, many with only a fieldstone marker—the Quaker custom."

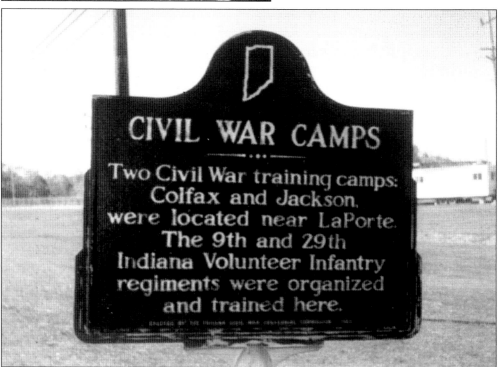

To commemorate the two Civil War camps which existed near La Porte, this Indiana Historical Marker was placed by the La Porte County Historical Society, Inc. and was dedicated on Saturday, September 21, 1963. It is located on the northwest corner of State Road #2 West and Colfax Ave. Camp Colfax was two blocks north of the marker location and Camp Jackson was located in "Stanton's Grove," one mile east of La Porte on land owned by Elijah Stanton.

The monument honoring servicemen and women who participated in the Liberation of Kuwait through "Operation Desert Storm" from January through March of 1991, was unveiled during the Memorial Day activities on May 27, 1991. The monument stands in Soldiers' Memorial Park along with other monuments honoring veterans from the various wars. It was donated by First of America Bank and Kovenz Memorial prepared the stone at no cost.

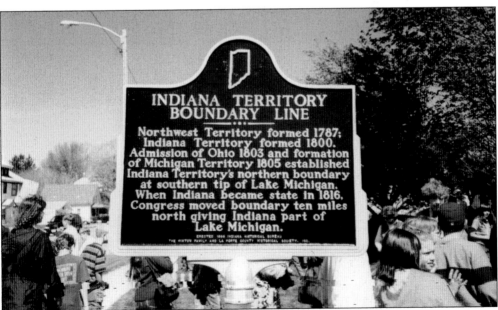

The Indiana Historical Marker designating the location of the Indiana Territory Boundary Line was dedicated on April 29, 1999. It is located on the grounds of the current Kentucky Fried Chicken Restaurant on Pine Lake Ave. This is the original site of the line, which is sometimes called the Indian Boundary Line and also the Ten-Mile Line. Funding for this marker was provided by the Indiana Historical Bureau, La Porte County Historical Society, Inc., and the Albert V. Hinton Jr. Family.

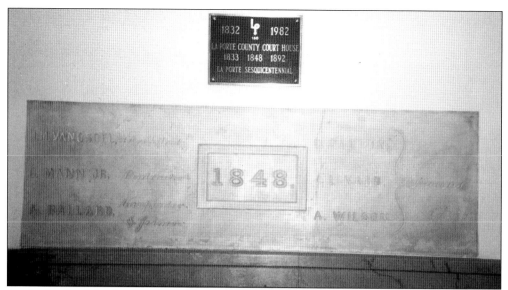

Inside the third (and present) La Porte County Courthouse, is this cornerstone of the second courthouse, built in 1848. Contents of this are unknown as it was not opened when the new building was erected. Names appearing on it are: J.M. Vanosdel, architect; L. Mann Jr., contractor; A. Ballard, carpenter and joiner, and masons D. Patton, J. Linard, and A. Wilson. The plaque on the wall above was placed in 1982 during La Porte's Sesquicentennial Celebration. It gives the dates of the three courthouses built on this same location: 1833, 1848, and 1892.

Trees are often planted as memorials. This marker in front of the tree contains a bronze tablet with text indicating the maple tree behind it was planted by the Service Star Legion. This was done in 1938 in memory of those from the county who served in WWI. It is on the east lawn of the La Porte County Courthouse.

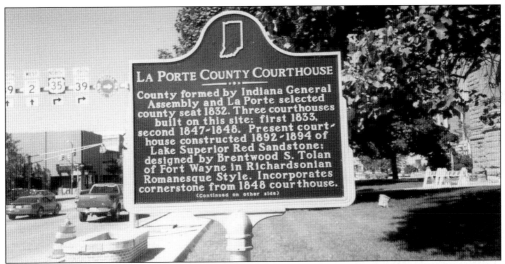

Dedicated on May 24, 2001, this Indiana Historical Marker is on the southeast lawn of the La Porte County Courthouse. This view of the marker is seen looking west and the text on the other side reads: Features include open-arched central tower, stained glass window transoms, wood paneling, and gilded friezes. Goddess of Justice stained glass graces courtroom. Tower has 272-piece glass skylight; gargoyles decorate exterior. Included in Downtown La Porte Historic District, listed in National Register of Historic Places 1983. This marker was funded by Indiana Historical Bureau, La Porte Co. Board of Commissioners, and La Porte County Historical Society, Inc.

The Excelsior Lodge of the Masons erected this marker on the east side of C St. between Seventh and Eighth Sts. with the unveiling on September 26, 1959. This area was known as Soapy's Ocean and as noted on the marker, was the meeting place in 1837-38 of pioneer Freemasons to form the first Masonic Lodge in northern Indiana. Traditional meeting places of the craft are "on a high hill or in a low dell." At this location, sentinels were placed on the high ground surrounding the valley and a Lodge of Master Masons was opened.

Throughout La Porte County, boulders with plaques and other markers may be found to honor veterans. This is an example of these types of markers and is on the south side of the entrance to Mill Pond Park at Union Mills. It was presented by Legion Post #295 in 1956. A previous honor board with the names of local service people listed on it was dedicated on December 17, 1944. It was later moved to this location where it stood until it was replaced with this plaque that honors all the war dead.

Various types of markers to honor veterans are found at the foot of a number of flagpoles. This one is located within the main entrance to Pine Lake Cemetery on the north side of La Porte. It is "Dedicated to the Memory of the Heroic Dead" and was placed here by the Hubner-Swanson Post #1130 of the Veterans of Foreign Wars.

The Daughters of the American Revolution have placed markers to designate specific historical sites. This one is in the park area west of the intersection of US#20 and SR#2 near Rolling Prairie east of La Porte. It was dedicated on August 1, 1969 and contains information about the importance of the Fort Wayne-Fort Dearborn Trail to La Porte County. The same day this marker was dedicated, the organization dedicated another for the same purpose on the east side of SR#421, just north of the junction with SR#2 at the northern edge of Westville. The fate of the latter is not known.

The Crown Bicycle Company was located at 1201 Washington St. and was important to the La Porte economy for many years. In 1987, the building in which it was housed was "headed for the wrecking ball," having been purchased by La Porte Hospital. Because the landmark crown was so in evidence on the front of the company's building for so many years, it has been preserved and may be seen on the site of the old building which was torn down.

On the northeast corner of Clay and Walker Sts. in La Porte, this American Revolution Bicentennial plaque placed in 1976 commemorates the La Porte University—1840-41, which obtained a charter through the State Legislature. The school provided for a literary, medical, and law department. The medical department became Indiana Medical College which later (1851) consolidated with the Indiana Central Medical College, a Department of Indiana Asbury University at Greencastle. This is now DePauw University.

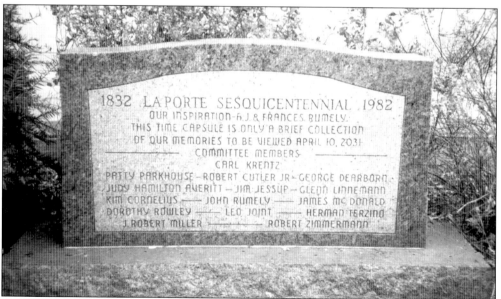

In front of the south corner of the La Porte City Hall, facing Michigan Ave. is the La Porte Sesquicentennial Time Capsule. It was buried on Sunday, April 10, 1983. The contents are to be viewed April 10, 2031, one year before the city's bicentennial. Most of the 200 plus contents were not reported but it is known to include a La Porte Slicers automobile plate, a Herald-Argus press page, an issue of TV Guide, and a videotape of the 4th of July Sesquicentennial Celebration. Bob Harris of Pine Lake Vault Co. etched the marker.

# Index